Praise for *Negative Space*

'Original, intense, and always compelling – this is a highly
accomplished debut.'
KEVIN BARRY

'There are few books that capture so gracefully and so truth-
fully the way in which art and life weave and bleed together.
Negative Space is a beautiful, profound, unique book.'
SARA BAUME

'I adored *Negative Space*. It is a personal *Ways of Seeing* for
twenty-first-century women. In a compelling personal story
steeped in art, Cristín Leach shows us how to look at and
make sense of what we can feel but cannot see, how to inter-
pret what it is to be human, in the same way that she so
skilfully interprets art. In this blend of memoir, life writing
and art criticism, Leach has written a powerful and moving
book. She beautifully articulates what it is to be a writer,
what it is to be heartbroken, what it is to be betrayed and
ultimately what it is to be human. It is essential reading.'
EDEL COFFEY

'In this extraordinary book, Cristín Leach sketches a vivid
sequence of vignettes that build towards a meditative
portrait of art, voice, loss and growth. Press your ear to this
book, and you will hear the tumultuous soundscape of a life,
in all its joys and sorrows and wonderings.'
DOIREANN NÍ GHRÍOFA

'*Negative Space* is a beautiful b⌐⌐⌐ ⌐⌐⌐ honest, and vulner-
able. Searingly intimate
LOUISE

D1380004

Negative Space

Cristín Leach

MERRION
PRESS

First published in 2022 by
Merrion Press
10 George's Street
Newbridge
Co. Kildare
Ireland
www.merrionpress.ie

9781785371912 (Paper)
9781785371929 (Ebook)

A CIP catalogue record for this book is available from the
British Library.

Typeset by riverdesignbooks in PSFournier 11.5/17

Cover design by Fiachra McCarthy
Front cover image: Portrait of the author
courtesy of Alex Sapienza
Back cover image: Portrait of the author
courtesy of Jill Cotter

Merrion Press is a member of Publishing Ireland.

'You can stand anything if you write it down. You must do it to get hold of yourself. When space is limited, or when you have to stay with a child, you always have recourse to writing. All you need is a pen and paper.'

— Louise Bourgeois

Contents

Writing

WHEN I FIRST STARTED WRITING ABOUT art for publication I had an editor who used to gurn down the phone, 'The piece is a car crash, Cristín.' In most cases it wasn't, but occasionally it was. Under pressure, something would snap, sentences would tangle, clarity would elude me. As the deadline approached, it felt as though words were conspiring to confuse me. I couldn't see the full shape of the thing. It was just a jumble of thoughts.

I felt helpless. The helplessness was a factor of panic. The panic came from anxiety, and I know now, physical symptoms of it. Fast breathing. Heat. Fuzziness in the brain that made the words, and the world, swim. Sentences refused to form. I was blind to what was wrong with sequences of words as I'd arranged them.

It felt like a form of self-sabotage.

Journalism has rules. I was taught never to write in the first person, even though writing about art had to include what I thought. And not just what I thought, but what I felt. The critic is part of the story, whether or not you can see them. The I of the critic is implied. Writing about art as a journalist must centre the facts and also come from your innermost gut instincts. It must be personal *and* objective. The American theatre critic George Jean Nathan once wrote, 'Impersonal criticism is like an impersonal fist fight or an impersonal marriage, and as successful.'

But what happens between the published words? What happens in the gaps, where as much is unsaid as said? This is where writing comes alive. Those gaps mean something for the reader because this is where the reader can insert themselves. Those empty places, as much as in the words that are written, are the places where readers can find themselves standing in front of that painting too, with their own history, biases, loves, hates, hurts, opinions and more. The gaps mean something for writers, too. This is where we bring ourselves to the page even when we are not fully visible. We give ourselves away in the spaces between the words if you look.

When I was ten, I won a short story competition which had a prize from a major British publisher. The prize

was to have your story considered for publication as a children's book. A letter came from Viking Kestrel, a division of Penguin Books. It said, 'Congratulations on winning the competition.' It said they enjoyed reading my story 'very much'. It said, 'it is always very difficult to publish stories of this length and we didn't think yours was quite strong enough to publish.' It wished me success with my writing and hoped I would carry on with it. I kept the letter, of course. I still have it. The contact details on the headed paper, still folded to fit in its original envelope, include an address for sending telegrams and cables. It was 1986.

I'm sure my mum gave me the narrative I went on to tell myself about that rejection: it wasn't that my prize-winning entry wasn't good enough for publication, it was just the wrong shape. She did that thing you're meant to do for your disappointed child, a child for whom how well she writes is somehow already a serious measure of herself. On the surface, I continued to tell myself that story: a piece of writing can be good, but just not right for a particular outlet. Underneath, I don't think I fully accepted my mum's neat, ego-soothing salve. I knew stories and books came in all shapes and sizes. I was in awe of Jayne Fisher, the nine year old with a book deal for her Garden Gang books. And so, what that letter meant to a ten-year-old was actually what it said: your story was good, but it wasn't good enough. It was a story about a family of cats, set in space. It was called

'The Tinfoil Pudding'. It felt like the pinnacle of my creativity at the time. The best story I had ever written. What more could I do?

Rejection letters are a rite of passage, part of the job, par for the course. Even at ten I knew that. Maybe I kept it because I intended to make it the first in a proud pile that would lead to eventual success. Maybe that's why all writers keep rejection letters. Still, I think that experience shaped my perception of myself as a writer, which is to say, my perception of myself. It was a message that said maybe the stories I could invent were good, but not good enough. I won the competition, but not the prize.

Two years before my brief dalliance with the children's publishing industry, I had won another competition for my writing. When I tell this story about my first journalism gig, I usually say the Irish national broadcaster's TV listings magazine, the *RTÉ Guide*, paid me in books. I can see how this narrative I've shaped about the interaction and the arrangement is not strictly true. They didn't pay me in books. The books were sent to me for review, I sent in my critique, and I got to keep them. To an eight-year-old reader that's getting paid in books, to a forty-six-year-old journalist that's not getting paid at all. I still have copies of the television guides containing the occasionally precocious, enduringly heartfelt responses I filed.

Memory plays games of course. I kept those letters too, from the Young Guide section editor Mary Finn.

According to one, I was also sent book tokens and other books to keep, ones I didn't have to review. Finn's letters were encouraging and contained the kind of phrases every aspiring writer wants to hear: 'Thanks for your last review, which was perfect. Here's another book I hope you like.' And there was my name in print. Publication and a by-line for something I had written, something logical, analytical, argumentative, opinionated. It planted a seed of self-definition in my head about me and my writing that was watered and bloomed when the Viking Kestrel letter came two years later. My job as a writer was to analyse other people's creativity, not to offer the world an imagination of my own. I was a critic.

But I was also an anxious kid. I can see that now. The first book review I wrote, the one that won me a book token and the job which lasted from April to October of 1984, was a kind of living nightmare to get down on paper. I recall crying, maybe even sobbing and wailing, and feeling it was an impossible task. I wanted to do it, but I was paralysed by the enormity of it. I felt I just couldn't. Then my mum said, 'just tell me what you thought of the book, Cristín. I'll write it down exactly as you say it, and you can copy it out yourself then. Your own words. You can do that. You've already told me what you thought of it.' So, I did and the review we sent in the post was exactly that: my words as I spoke them, written down. She taught me, whenever I'm stuck, to just say out loud whatever it is

I have to say, and write those words down as a starting point. It was a lesson that stuck. I remember writing the rest of my assignments without issue, happily cutting out the middle-mum.

But that feeling of panic, the near hysteria as I recall it, of the enormous importance of doing a good job on that first review, remained with me not just in my mind but as an emotional and physical experience on an almost cellular level. It came from inside. A heartbeat driven by a rush of adrenaline with nowhere to go, a blank feeling in my brain, heat. I can still take myself back there. There's a glitch, an inability to find clarity, a desire to run away but a necessity to stay put.

It is 2008. I am driving in the Dublin Mountains with my kids. They are both under two and they do not sleep well or for long at night without waking. They do not have regular, predictable naps. They are wonderful and remarkable and I love them, but minding them is also hard work.

On the radio the poet Seamus Heaney is talking. He says a writer is someone for whom how well they write is a measure of themselves. That's all. A writer is not a person whose writing is published. A writer is someone who writes because words are part of who they are. You could say then, for a writer, how well they write is a reflection on how well they are succeeding *as a person*. Heaney was talking about time spent teaching

poetry at Harvard University before he won his Nobel Prize for Literature. It was part of an RTÉ Radio 1 documentary. He was talking about the students in his class. What he said stuck because it spoke a certain truth, but I wasn't sure I'd remembered it correctly. Months later, I found the documentary online and played it back. I had misremembered the quote, if not the gist of its intention. At my desk, I typed his words as I listened. 'Talent is one thing,' he said to the presenter, 'but I think having some kind of dynamo, some kind of impulse and motivation is another thing.' And here it came, the quote: 'There are three or four who will continue to think of themselves as writers, that is to say who will continue to estimate their own identity through how well they can write.' He had put it better than I recalled.

Something else was going on when I panicked as I wrote, something to do with what Heaney had said. I had to learn to overcome that tendency in myself to crash when overwhelmed with the prospect of writing something that meant a lot to me, specifically something *for publication*. Because a measure of how well I was writing really was a measure of me. I had a feeling that it was important to tell a good story, to write something worth reading, not just as a way of expressing myself, not just as a way of doing the job well, but as a justification of my very existence.

In my late thirties, a text message arrives to say my husband has been cheating on me. And the panic attacks start again. This time, the panic feels like it might kill me. This time, it is so strong, some days so all encompassing, it feels like it's trying to make me cease to exist, trying to take me away with it, trying to protect me by making me disappear completely. Suddenly, all the words I have ever known mean everything and nothing at once.

I learnt to read before I started school. I was three. I don't remember a time before written words were how I understood and explained the world to myself. Looking, seeing, and translating what I saw into language, translating language back into pictures in my mind. Words were my friends.

But words can also be weapons. They can hide as much as they reveal. Words are solid and slippery things. When my marriage broke, I came to distrust them for a time. I've since realised that I trust them now more than anything because they always contain what you need to know, somewhere, somehow, if you are really looking, if you know how to read them, if you are not distracted and you are really paying attention.

I didn't always know that.

It is November 2014, and I am writing a book review for *The Sunday Times* when I get the text message to say my husband has been cheating on me. Even now, writing that sentence sends panic into my body, my hands get cold and start to shake. I had no idea that hand wringing was a spontaneous, uncontrollable action directed from deep inside until that day. I thought it was a performative gesture enacted by characters in books, a visibly dramatic handy shorthand for distress.

I was reviewing *Art and Architecture of Ireland*, a five-volume, 3,000-page tome with ten different editors, published by Yale University Press. I have had to go into my laptop files to find this out, because I have no memory of what I wrote or how I finished and filed the copy on time. I see that I wrote, 'It's rare that a set of books matches the hyperbolic self-description that accompanies it, but in the case of this remarkable project from the Royal Irish Academy, "the most comprehensive study of Irish art and architecture ever undertaken" is a fair and accurate call.' I do not remember reviewing this book, but I do remember that after the panic, the shock, and the shaking, I did the work calmly and with focus. The words and the job were a refuge. I somehow put my feelings on hold to finish the writing task. My body was so full of adrenaline that, instead of screaming or fighting, I went still, and I went to work, with words.

Shock and panic came in waves in the weeks that followed as school runs and homework and dinner still

had to happen as my world was falling apart. Initially, I told no one.

Driving to Kilkenny five days later to see an exhibition, I sat in a gallery room in the basement of Kilkenny Castle and let artist Amy Walsh's video works fill my mind. Refuge from the endless repeat loops of panic, circular thoughts, pain, heartache. I sat there fully immersed. Art is an escape, art is an embrace, art shifts perspective.

I wrote in my notebook,

You might imagine the vast proliferation of remarkable, beautiful, amazing, awe inspiring, shocking and even heart-melting images on the internet – made often by non-professionals with everyday equipment in various settings – has made us immune to any kind of special impact a digital image by an artist in a gallery could provide. You'd be wrong.

I wrote,

Walsh's Kilkenny show is an uplifting, mysterious reminder of the beauty of this earth.

I wrote,

A soundtrack of birdsong, buzzing insects, night sounds, crackling leaves or branches and a low rumbling beat like thunder or wind on an unprotected microphone (or bangs like drums or gunshots, the shuffle of outdoor feet) accompanies the two high-definition video projections. The rest are digital prints, glossy, liquid-surfaced stills.

The videos are screened with reflective surfaces on the floor below, resulting in a mirror image that amplifies their beauty, transcendence, sublime quality.

The speed at which the images move is key. A slow shift and curved roll that reminds us of the shape and movement of the earth. Like a million shooting stars captured over time as they leave their trails. These are animated long exposure photographs shot in New South Wales at night. In the Australian bush there is no man-made light pollution. There are real shooting stars and lights that flash and extinguish, come and go on the horizon.

I wrote,

The final room contains the second, a faster kaleidoscopic image that glows and shifts and sounds like earth and reminds us of the wonder and importance and insignificance of it all.

The published review was more formal. I described Walsh's videos as 'some kind of transcendental triumph'. A 160-word slot for capturing an exhibition is a tight fit in any case, and a newspaper critic does not bring her personal problems to the pages of *The Sunday Times*. My job was to make things neat with words. My job was to articulate and explain. My job was to look, and, more importantly, to see. I was good at it. How strange then that I had not really looked, that I had not really seen that the neat thing that looked like my marriage

was not neat at all. How strange then, when words are so important to me, that so much was unsaid.

It is January 2015. The Crawford Art Gallery in Cork runs a creative writing competition. Everything is broken and I am lost. I feel like I have no idea who I am any more. My husband and I have started counselling. The Crawford competition invites participants 'to write creatively' about an artwork in the collection. Two stories pour out of me. I write 'Portrait', inspired by *Portrait of the Penrose Family by Robert Hunter* (1776), and 'Fake', inspired by John Hogan's sculpture *The Drunken Faun* (1826). In retrospect, perhaps 'Portrait' was just too unpleasant to read.

Portrait

She held on to his arm as if to hold him back, as if to say, 'Leave it. The bird will be alright. And if it isn't, what matter?' It will have amused the children for a while. Maybe long enough for this painter to get his angles right, the expressions done.

She didn't like the portrait when it was finished. And she couldn't understand why her husband did. He looked exhausted, ineffectual, beaten down by life and its ordinary problems. No more than she, with her reddened fingers and flattened chest.

The spark in her son's eyes: an artificial one. The smile on her three-year-old daughter's lips, concocted purely for the scene. It wasn't how she remembered it. The dog beseeching, asking to go out. Yes, that was right. Her son's top three buttons undone, even though she had fastened them, twice, on both occasions, before they began.

She wondered how the painter had decided on their stances. She had been unsure about the ill-fitting coral dress, lent by her sister. Too skinny to fill it out, but with unexpectedly strong arms; she knew that. And that stupid bit of fabric flung over her shoulder and across her front to bulk up or maybe distract from the boyishness of her form. It didn't work, she knew. It only drew attention to her fault.

Earlier that day, their son had come in from the yard, a strange-looking bird in his hand. Long beak, white chest, round head. 'It's injured Mamma,' he said. And she had taken a look and reached for a box, lined with some cotton fabric she had kept, just a swatch. They lay it inside and waited and watched, the only movement the too fast rise and fall of its chest. Its head lolled to the side.

'Leave it,' she said, 'Go and play with your sister.' And for once he went, without complaint, his face a map of concern for the creature he had caught. The dog came over and sniffed it. 'Get,' she snapped, pointing to his cushion by the grate. Head down, he made his way to the hair-covered pile and nosed his way into the nest made in the shape of his body every night.

In the room next door she could hear scuffs, shuffles and bumps as her husband cleaned his hunting rifle. 'I'll need this for the painting,' he said. 'Can't he just paint one in?' she asked. He looked at her, defeated again. 'I suppose so.' But still he took the gun to his study and began the task. It was better when he was busy.

She had already planned to ask the artist to paint her a good handbag. What he produced wasn't what she had in mind, and you could hardly see it behind the dog's head. Hardly worth it. A symbol of wealth. Still, worth including, she told herself, just in case.

Annabelle came down with the nursemaid, holding hands. White dress, green sash, just as she'd ordered. Hair tied up with a band across, to hide the scarcity of it. He'd make it blonde. That's what they did.

She wasn't entirely sure what all this pretence was for. Well of course she was, but still. It felt like a lot of effort for nothing of any real worth. A portrait of the perfect family? A son and heir, rosy cheeked, round-faced and fresh; a blonde daughter, to marry off. A husband so weak even his arm across the back of the chair fell foppish, inert. He slumped in his seat as the time went on, as the children were given a break and played quietly enough by the fire with the nurse. She held her hand on the lower part of his upper arm and fell into a kind of reverie, filled with thoughts she never intended the painter – or anyone else – to catch crossing her face.

She was remembering the time she saw him through the slats in the stable door, his tan leggings about his

knees, the ends of his waistcoat flapping against his pale pink skin. The shake and shudder of his body as she took note of the shape of the shoes between his feet, the colour of the dress, the petticoats gripped tight in his hands, the bare legs. She looked over at the nursemaid. Then she moved to stand a little taller, pressed her thumb hard into the hollow just above his elbow and he slumped a little further in his seat.

There are three winners. I am not one of them. I am an art critic. I am not a short story writer.

I think about the poet Emily Dickinson with her hand-sewn packets of verse, hidden in a drawer, writing 100 years after this painting was made, writing a century and a half before me. A writer is someone who assembles words to please herself. She is her first reader, her first audience. Only when she is satisfied, or pleased enough, or ready to receive advice because she knows she cannot get better without it, will she show her writing to someone else. What she wants is to be told yes, this is good – you are a writer, look you hold in your hands the proof.

Writing has caused me panic, and writing has anchored me. Words have saved and confounded me. When I was eighteen, I blanked while writing an essay during

an exam for a financial scholarship to go with a place on a university course that was already mine. I was going to study English. It feels now looking back that I cared too much, as if there was some part of me that wanted to trip myself up on the journey towards the thing that meant most to me. I didn't understand until almost two decades later that what happened in the exam was a brief, catastrophic attack of anxiety. Catastrophic only in that it caused such a blind spot in my brain I could not fix it; I could not get past it. I wanted to leave but I had to stay, I wanted to run away and never write another word, but I couldn't.

I had to pen an essay on a dictated topic, and I could have done it by thinking sideways or writing about how much I hated what I had been asked to write about or any number of ways I would approach it now, but I froze and I blanked and I ploughed through, writing by hand until the bell rang and it was the end, and I knew I had failed. It seems strange and unreal to relate this now, and my mind has deleted so many of the details of what actually happened that I can't quite understand how it unfolded or remember anything but the error. I remember the panic, the heartbeat, the breathing, the heat, the blank. I spelled the word soccer wrong in an essay about soccer, throughout.

I remember writing, frantically, messily, brain racing, heart beating, sweating, quick breathing, on the piece of rough-work paper we were allowed, the three possible options as I saw it: soccar, soccor, soccer. I can see

the words now, and I can remember being absolutely, irretrievably blind to which was the correct spelling of the word. I believe I chose soccor and proceeded to use it in the first sentence and many other sentences throughout my doomed composition. I know I did not choose the correct one, because I remember leaving the room and knowing immediately, clearly, absolutely how to spell soccer. And knowing I had got it wrong.

The writer Elizabeth Bowen once wrote, 'The importance to the writer of first writing must be out of all proportion to the actual value of what is written.' From a very young age, I believed in the alchemy of words, that they contain a kind of magic and that, like a superpower, writing comes with a responsibility to serve the words well, or they may not serve you well back.

Years spent writing as a journalist can bestow some gifts the value of which plummet when it comes to writing fiction and other arrangements of words: an understanding that every sentence must be backed up by verifiable fact, a habit of taking the feelings out, a belief that any writing that doesn't end up published and paid for constitutes a waste of your time. It is not.

Writing and rejection are bedfellows, they will always lie beside each other, sometimes inextricably intertwined, for those for whom the words they write, on any given subject, represent illogically, irrationally,

maybe even inexplicably, the most urgent and necessary measure of themselves. Writing comes from deep within. It's personal, it's precious. Words keep secrets and reveal. Even as a child, I didn't know if I wanted to let all of the words I had in me out.

When panic became a factor in my life again, it had nothing to do with writing. It came from a shock discovery, a reaction to an external event. It was the shape of my life suddenly falling apart, a loss of control. And yes, rejection. A marriage that was good, but not good enough. And I turned to writing because words are something I have always felt I could control. They are my way of putting shape on the world. Of fixing it, in both senses of the word. When I am not ok with the world, I am not ok with the words. Maybe if I can be ok with the words, I can be ok with the world again.

Seeing

I THINK OF MY MUM WHEN I look at the handle of a cup. When I was six or seven, she taught me to draw by teaching me about negative space. That is, how to draw objects by drawing the gaps between them, by drawing what they are not. She showed me this by getting me to draw the shape made between the straight side and the inside of the handle of a cup. The shape I drew was a D.

In the bath, when I was much younger, our mum showed my sister and me how to join the forefingers and thumbs of each hand to make a shape like the symbol of a playing card spade. It was a shape to be filled by dipping it in the water to catch a film of bubble bath liquid, forming a rainbow shimmer surface to blow. The negative space between my fingers and

thumbs reminded me of a Christmas tree, but I never told anyone that. Some words stayed inside my head. The bubble would undulate like a flexible sheath, back and forth at the pull of our breath. It formed a shape that only existed because of the flesh form around it. Break the seal where the skin of fingers and thumbs meet and the bubble breaks. The Christmas tree is gone. It made me think about *Alice Through the Looking Glass*, which I read repeatedly from the age of six. The idea that a person could look through a threshold no one else had really noticed, and that what was on the other side would be different but the same.

If you are taught from a very young age to look at the negative space, it does something to how you see the world. It leaves you with a certainty that sometimes what is not shown or seen is as important to giving an object, a concept, a situation or an experience its shape as what is apparently solid and visible. You are left with a certainty that, if you want to portray something, drawing what is around or between it and the rest of the world will illuminate it, throw it into relief, or result in an actual portrait of it just as well. And maybe better, because not looking at the thing directly, focussing on what it is not, will still in the end reveal, to you and to others, what it is. But this way of seeing is also a way of moving through the world without looking directly at things.

It is November 2014, the day before I receive that text message. I return home late at night to find my husband on the sofa watching TV and our kids in bed. I have just had a remarkable experience at the prize-giving event for the inaugural HearSay International Audio Arts Festival, for which I am a prize judge.

I have come from interviewing the winners on stage in a deconsecrated Protestant church in the village of Kilfinane, County Limerick. In that cold, stone building filled with audio makers from Iceland, Argentina, Turkey, Canada, England, Ireland, the USA, we heard the overall winning piece again, *A Kiss* by Kaitlin Prest. I am so utterly bowled over by this piece of audio that I play it to my husband as we sit together on the sofa. 'Listen to this,' I say. 'Listen to what is said and not said. Listen to how two people experiencing the same thing can be experiencing not the same thing at all. Listen to how two people can be so embedded in their own perception and understanding of an action or event or situation, that the other person's experience, perception, and understanding is actually a different story, altogether.'

Kaitlin Prest's *A Kiss* begins, 'The sun was pouring into my bedroom. There is something about the afternoon that turns me on. There is something about that lazy alertness. I just want to dive into my bed and I dunno, make out. This afternoon in particular, there was a boy in my bed. The last time I saw Kyle, we were saying goodbye.'

The audio mix in this piece layers the voices of Kyle and Kaitlin as they recount from their own perspective, separately, but together now in this audio edit, their experience of the same kiss. It is so powerful because of its flat-out demonstration of a fundamental disconnect that is not visible, that is not spoken, that is clear on the inside but in no way explicit beyond that.

By 2022, *A Kiss* has been played more than 2,300 times on the HearSay Audio Prize Soundcloud, and at least twenty of them are me sending people to listen to it. It is six minutes long, but it contains a galaxy of truth about human connection, and disconnection.

The prize calls for 'composed, compiled, or crafted audio'. It celebrates creativity merged with actuality, fiction blended with fact. *A Kiss* offers all three: composed, compiled, crafted. She says, '... and it was unremarkable', just as his voice tumbles in afterwards to say, '... and the kiss was beautiful'.

On stage at the festival, I asked Kaitlin how she made it. She says she recorded her own piece and then she rang Kyle up and asked him to record his memory of that nap on that day and that kiss and send it to her. He hadn't heard what she had recorded. She took the two pieces of audio and made this moody, atmospheric, intimate, surprising, prize-winning audio tale.

I am excited by the potential of this blended format where memory and perception clash and dance. I come home bouncing. I play it to my husband and he likes it, although he is not as elated about the

story or the format as I am. I realise much later, much after the fact, that maybe I am excited because I recognise the disconnect. Maybe I am enthused to hear it articulated, maybe I know without knowing that when we kiss, we are not telling ourselves the same story, we are not experiencing the same kiss. Maybe I know without knowing that something is wrong. It is Sunday night. We go to bed. The next day the text message arrives.

In the days that follow I spend some time shovelling gravel into potholes on the long driveway that leads from the gate to the house where we live high up on the side of a mountain. Dig. Dig. Shovel. Carry. Toss. Repeat. I walk away from my laptop to do this in between drafts of the article I am writing. I channel the panic into action. Fill the potholes, hit the deadline, even though your life is falling apart.

It feels like there is a lot of judging going on, that I am being called on to cast judgement, and I am. The week before, I was writing about the Hennessy Portrait Prize at the National Gallery of Ireland. I published a piece in *The Sunday Times* that began,

> Everything's a contest nowadays, even better if it's a public one: audition before a baying crowd, bake a cake under studio lights and pressure, paint a portrait live in four hours on TV. Early twenty first century audiences like their competition cruel and atavistic.

If at all possible, it should involve open spectacle and expose failure alongside success, each rejection a form of entertainment. In light of all this, there is something delightfully civilised about the National Gallery of Ireland's inaugural Hennessy Portrait Prize, for which I am a judge.

We pick the winner by consensus. There are three judges. But the best piece in the show for me was not by the artist who won. The best piece in the show later ends up in the National Gallery of Ireland collection. It's a self-portrait video by Saoirse Wall, who has just graduated from art college. She is in the bath, biting her lip, dipping her fingers in the water, daring you to look at her, which of course you are, because she's asking you to. I write about her 'accusatory stare'. The piece concludes: 'If reality TV has taught us anything, it's that sometimes the runners up do better than the overall winner. Being shortlisted is a serious mark of endorsement. You don't always have to win the competition to ultimately win the competition.'

Was this a note to my future self? A note to my past self?

After the review of *Art and Architecture of Ireland* was submitted I spent three days in bed, during which I refused to make the dinners, do the school runs, homework, laundry. I couldn't get up. We told the kids

I was sick, and I was. Head sick. Heart sick. I felt like I'd been shot at close range. The hand wringing was difficult to stop. I felt as though any movement could be explosive. I was containing rage. I was absorbing shock. I was holding panic in my body by crashing out. I cried. I felt nothing. I felt it all. I wanted to disappear. I wanted everything, including me, to stop. On the fourth day I got up and started cooking, driving, doing housework again. On the fifth day I drove to Kilkenny to see some art.

The Butler Gallery is a basement gallery underneath Kilkenny Castle, and it is a place I have known since childhood. We lived, from when I was six until I was fifteen, in a 200-year-old farmhouse just outside Castlecomer about thirteen miles away. My mum is an artist. I am her first child. She says I've been going to exhibitions since I was in the womb. It might explain why I feel at home every time I walk through a gallery door, every time I stand in front of a painting, every time I look over, under, around a sculpture, every time I sit in a darkened space, watch a film, or listen to a piece of sound art. I grew up in Kilkenny, for the most part. This gallery in the basement of a castle is part of my becoming.

I decided in that dark space filled with images of the universe that I would try and fix things, that I would try to fight for my family to stay together, for my marriage not to break.

In December, I go to cover a show at The Crawford Gallery in Cork called Motivational Deficit. My husband and I are already in counselling. I open the published feature with this:

> 'Who would want a risk-free world?' asks the investor playing poker with a banker, an economic researcher and an artist in a video installation playing at the Crawford Art Gallery in Cork. Well, lots of people, you might think, but no. According to the researcher, 'when no one's taking any risk, nothing is happening.' The others nod. 'If everyone saves, everyone goes broke.' More nodding. It turns out, 'everything's a risk ... the only question is how big a risk is it?'

I'm writing about Michelle Browne's video, *Risk*, screening upstairs, separate to the main body of works in this group show.

I write,

> It might be the best piece in the show. Or is it? That accolade might fall to Eoin McHugh's hyper-real painting, David Sherry's ingenious audio art or Orla McHardy's video projection in which a mechanical toy horse goes round and round the plastic stick to which it is tethered. The question arises because this exhibition is about assigning value, asking questions, becoming curious, wary, cautious, upset and in the end, taking some risks.

I have been married for ten years at this point. I am

blindsided by the knowledge that my marriage is not what I thought it was. I didn't realise or understand that negotiation of risk was part of it. But now I start thinking about values, about change, and about risk, about what happened, what's happening now and what might happen next.

The notes I write in my notebook are different to the words that I publish, and the same. I alter them with tone of voice. I add to them with research. I leave thoughts in and take thoughts out. When I spend time looking at art for work, I handwrite a deliberate stream of consciousness in the gallery which I later use to write the finished piece. By 2014, I've been doing this work for more than a decade and I have learnt that the closer I get this stream of consciousness to full sentences, the faster I will be able to write the piece for publication, even if most of these words get the chop. I write hundreds, thousands more words than ever get published. If the piece must be 1,200 words long, I begin with a document of notebook-transcribed notes that is often two, three, or four thousand words long. Specific, intimate, detailed descriptions of individual works made on the spot, in the moment, get dropped as I edit, when they do not serve the bigger narrative of the review, when there is not enough space, or when they are too intimate or too explicitly personal to print.

The journalist in me includes medium, titles, timings, sizes, dates. In my notebook, I have written:

*In Orla McHardy's Good Friday (2013) HD video
(24'26"), a battery-operated mechanical horse, a child's
toy/plaything, circles and circles and circles a plastic stick
to which it is tethered. The stick is held in the centre of a
piece of hardboard by Sellotape. The horse keeps falling
and a hand appears to pick it up and start it on its
track again. But it doesn't appear immediately. There
are repeated moments where the horse falls and its legs
keep moving in a helpless, useless, automatic movement,
struggling ineffectually like a beetle on its back.*

*The horse is doing what it's supposed to do, but it
cannot maintain its own momentum. It's a victim of
its own instinctive/pre-prescribed/allocated activity. It
must keep going, but it is doomed too, to keep falling
down. The metaphor is clear: the system is broken, it
doesn't work.*

I feel an affinity with the mechanical horse. A neat
fraction of these thoughts makes it into the final piece.
With my notebook I move through the show. I write
about Anthony Haughey's *Settlement* photographs,
shot in ghost estates filled with abandoned, half-built
Celtic Tiger homes.

I write,

*The glow, the beauty, the tragedy, the loss. More futility,
abandoned hopes. Housing units/homes at the end of
overgrown tracks, with mounds of moved earth, never
levelled, now covered in green weeds and grass.*

I am trying to save my marriage. I don't know what will happen next. This exhibition is about things falling apart. In my notebook, I write,

Ways we can physically move on, even though everything is shit. Even if mental, emotional ... scars remain.

I write notes about Sonia Sheil's work.

Her paintings are brown and bleak. Consent Volenti (2014) contains a warning notice framed and perched on a stick, two bulldog clips like a planning permission sign. It says, Statement of Inherent Risk 'appreciating art is a hazardous activity that carries significant inherent risks of personal and psychological harm or injury, including confusion ...' the viewer is advised among a long list of other things that 'communication may fail between artist and viewer'. It's good to point out the problem, but it's still not good to be the problem. Pointing out the problem doesn't fix it/make the problem go away. In the absence of other certainties, at least Consent Volenti is honest and honesty is probably the most any of us can hope for at this point.

I have told my husband I want him to be honest. This painting is an assemblage piece. It includes a real cuckoo clock. I write,

The ticking of the clock is another inevitable soundtrack to this show, along with the click clack of the mechanical

*horse and Sherry's enticing narrative drone. It's time
passing, moving inexorably on, whatever state we're in,
whether we like it or not.*

I come to Michelle Browne's *Risk* at the end of the
show. I write,

*'What is something that you wouldn't risk with?' the
artist asks. She wants to know if having a family changes
your attitude to risk. They don't answer it at first, they
seem reluctant to, so she asks again. It depends, they
say. 'You have to take risks to provide', the investor says.*

I write,

*It's a good conversation to eavesdrop on. Talking is one
way we can learn what happened and what might/could
change so it doesn't happen again, in the same way.*

I am talking to myself about my marriage, in my note-
book, in the gallery, with this art. Browne's film was
made three years after the 2008 Irish banking crisis
and collapse. In the published article I conclude,

On the first day of the Oireachtas banking inquiry, a
week before Christmas, the Finnish banking expert
Peter Nyberg was asked, 'how bad was the Irish banking
sector at misjudging risk?' He laughed as he responded.
'The Irish institutions were pretty good at misjudging
risk,' he said.

I think, I have misjudged risk. I think, I have failed to look at what isn't there, failed to look at what is missing. Have I been so preoccupied with the negative space that I've failed to look at the thing itself?

To draw a skyline, you must draw the line between what it is and what it isn't. It's the line that marks the moment when the ground ceases being and the sky begins instead. Like the line between an object and the space around it, this is a border, an edge. It's the difference, the moment of change. A skyline exists in the tension between the two. A marriage exists on the border where two people meet.

In 2010, I reviewed an exhibition at Lismore Castle Arts by the Irish artist Gerard Byrne entitled A Thing is a Hole in a Thing it is Not. The phrase comes from a body of work by American minimalist Carl Andre, who proposed that an object could be considered 'a cut in space'. It's a fairly nihilistic thought: that anything, in and of itself, is actually some kind of gap or nothingness in the whole body of everything else. But it's also an evocative phrase for a woman interested in negative space. A broken marriage is a hole in a thing it is not. A broken heart is a hole in a thing it is not. The letters on this page are a hole in the paper, a page on a desk is a hole in that desk. If everything can be

further illuminated, defined, or articulated by casting light on what is around it, then everything is a hole in a thing it is not. The idea of anything being seen by the fact that it is not something else is an idea that insists on pointing to the importance of the threshold between presence and absence.

Andre was acquitted of the second-degree murder of his third wife, the artist Ana Mendieta who fell to her death from a bedroom window after an argument with him in 1985. He still lives in the 34th floor apartment in New York, with his fourth wife, the artist Melissa Kretschmer. There are those who still argue about what happened that day. He told the police he was not in the room when she fell. No one else was there to see it.

My mum taught me another word to do with drawing: eyeballing. To eyeball something is to draw it from life, to draw it by looking intently at it. If I eyeball you, I look you in the eye. I look directly at you. But the magic of negative space is that it shows you how to eyeball something without looking it in the eye, without looking at it directly. You can eyeball something by looking just next to it, by eyeballing the space around it. What you are left with is the shape the thing makes in the space where it is not.

Is this only an outline? Yes. Does it articulate the shape of the thing? Yes. Is it the full picture? No. And yet still, my approach to life has been hugely influenced

by the idea that sometimes what isn't there is just as important as what is.

Ten months after writing about art and risk, I review a show about love. The counselling is coming to an end. It is September 2015. By that November, we will have decided to split. The Irish Museum of Modern Art puts on a large group exhibition called What We Call Love. I love this show a lot. It is about pain and pleasure, but what I find mostly in it is pain. The artists in this exhibition include Picasso, Brancusi, Dali, Duchamp, Man Ray, Andre Breton, Max Ernst, Meret Oppenheim, Louise Bourgeois, Marina Abramovic, Sophie Calle, Yoko Ono, Rebecca Horn, Nan Goldin and Ireland's Dorothy Cross. Most of the women come later in the chronology. In my published review I write,

> This is an unashamedly sensual show, by turns erotic, repulsive, shocking, challenging and yet repeatedly, throughout deliberately thoughtful. It comes prefaced with a warning about adult themes and explicit imagery, which parents with children may wish to take into account. The rest of us should be big enough to face what it has to offer head-on: bare skin and genitals, kissing and heartbreak, intimations of sex (it stops short of porn) and the inevitable isolation that comes when love doesn't work out.

I am writing to myself, for myself.

I write about 'Dali's couple, who share a world but remain forever separate'. I write about the 'idea of love as a sting, and the concept of couples engaging in a kind of dance in which they consume each other'. I write about 'an arc that can be traced from the earliest works here, dating from the 1920s, to now. It reveals a kind of progression towards a culture of thinking a lot more about sex and a lot less thinking about intimacy.'

I write about objects made to fill holes, and objects articulated by the space around them, including Duchamp's *Wedge of Chastity*.

I write about Sociology professor Eva Illouz's *Why Love Hurts* (2012) DVD, which is included in the exhibition, and her accompanying essay for the show's catalogue, which asks 'Do we still need couples?'.

It's a question I'm asking myself. I think not.

I write how Brancusi's carved limestone sculpture *Le Baiser/The Kiss* (1923–25) 'presents love as an insular, self-sufficient ideal, forever and immutable, set in stone; when the argument this show convincingly puts forward is that everyone knows it isn't.'

Those are the last words in the review.

But another piece from the exhibition lingers in my mind. Dorothy Cross' silver *Kiss*, cast in 1996, is a negative space object. It's a hole in a thing it is not. Made from a mould produced from modelling material formed in the mouths of two kissers, it captures the gaps where two mouths meet. It is air made silver. Teeth, gums, lips, roof of the mouth. It is the inside

brought outside. It looks brittle. It looks bony. It looks mechanical, cold. It is that intangible thing: a moment that might mean one thing to one person and something else to another. It is the invisible made visible. Emptiness given shape. It is the intimate made explicit. The fleeting made permanent. It is the unspoken captured, made visible, fixed. It is the ordinary made precious, the beautiful made ugly.

Listening

I T IS 2015 AND I'M LYING flat on the square concrete
slabs at the back of my parents' house, feeling shifts
in texture beneath my back and legs. The slabs are
interspersed with gravel, chequer-style, to make fifteen
squares fill a space that would otherwise need thirty. It's
a small-to-medium-sized back garden in a medium-sized
1990s housing estate just outside Cork city, the place
we moved to when I was sixteen. I am thirty-nine now.

'There's no such thing as silence,' I say.

'Except, in the moment just after you pump up a
bicycle tyre so much that it bursts,' says my brother
as we relax in the garden, lazing around.

'Oh yeah. I've done that,' says my dad.

'What?' I ask them, 'who blows up a bicycle tyre
until it bursts?'

'Me,' volunteers my brother-in-law from his seat on the bench by the wall. 'If you keep going, a bubble forms and it goes kind of thin.'

'You know you've gone too far just before it happens, but then it's too late,' says my dad from the deckchair.

'You've blown it,' says my brother, and they all laugh.

'Why would you do that?' I ask.

They shrug and smile at the pleasing shock of the memory. 'Because you can?' offers my brother.

I think it's strange that three of the closest men in my life, with decades between them, have all done something I think I would almost certainly avoid even risking. They've all pushed to the limit an action requiring delicate measure and restraint. They've all damaged something beyond repair, with a kind of fearless curiosity.

'How does blowing up a bicycle tyre cause silence?' I ask my brother.

'I looked it up,' he says. 'Something happens to freeze the bones in your inner ear, and everything stops. Silence. It's pretty scary; you're not sure if your hearing is going to come back.'

This is noise-induced hearing loss, I know now, because I looked it up too. I didn't check what he said about the bones, but I liked the idea of everything freezing, everything stopping for a moment. No ringing, no buzzing, no high-pitched singing, no ambient sound, no nothing, no noise.

In September 2013 I started to develop tinnitus. It began like a dull muffling that went on to become occasional buzzing before transforming into ringing so loud and so incessant I had to wear headphones attached to a white noise application on my mobile phone just to distract myself from it long enough to fall asleep. It was the first thing I heard every morning and the last thing I heard at night, unless I listened to the soft rainfall, airplane drone, or birdsong offered by the apps. Even then, I knew I could still hear it if I tried. It wasn't gone, it was only masked. I was thirty-seven.

The start of the ringing coincided with the beginning of my husband's affair. It was a deceit that didn't come to light until more than a year later, but it is hard post-facto not to interpret the tinnitus as some sort of warning sound, an internal bell, an inner alarm, a siren, audible only to me and with a meaning I didn't understand.

One thing tinnitus does is to make you feel like you are going mad. No one else can hear it. It feels endless. It is endless. It is ever present. You are naturally being driven to the brink of what is tolerable by an inability to escape from the sounds. The fact that no one else can hear it only makes it worse.

I went to three different GPs. The first one told me to practice unblocking my ears by holding my nose and blowing. The Valsalva Manoeuvre. The second one embarked on an oddly awkward anecdote. Here's how it went:

'A crazy thing happened to me once,' said the GP as he poked about in my ear with his otoscope.

'Oh yeah?' I said, clenching my jaw at the discomfort.

'Yes, my wife hit me. By accident, of course. She was just putting something in the cupboard, and she stood up and swung around and whatever way she moved she swiped me across the jaw. Just like that.'

'How strange,' I said, distracted momentarily from the endless buzz. 'How on earth did she do that? Did it hurt?'

'Well, she's much smaller than me, but yes it was quite a whack and what happened was I ended up with this ringing in my ears as a result. Just for a while,' he said. 'It took a few days to go away. Whatever way she caught my jaw. You know that phrase "ears ringing from a box in the jaw"?'

He trailed off and busied himself with the otoscope, poking harder. It hurt. I winced but said nothing about the pain.

'Anything like that ever happen to you?'

'You mean did someone hit me?' I said.

'Yes, because you know even a small blow, even if someone didn't mean it, could have your ears ringing ...'

'No one hit me,' I said. No one had.

'Ok then,' he said.

That GP told me to see a dentist. The dentist diagnosed TMJ, temporal mandible joint disorder, and recommended exercises to relax my jaw and possibly a mouth guard. She noticed that I'd been chewing

the inside of my cheeks in my sleep, or perhaps while awake. She said this was the result of grinding my teeth. I hadn't noticed it.

'Why do people grind their teeth?' I asked.

'Lots of reasons,' she said, 'subconscious anxiety, stress'.

'But what do I have to be stressed about?' I said. No one answered. 'My husband is travelling a lot right now but there is no reason for me to be stressed.'

I looked at the dentist. The noise in my ears got louder. The dental assistant moved to the other side of the room. The pitch got higher. I started to cry in the chair.

I began doing the exercises every night. The sound was no longer ever at the low-grade humming level where it had begun, the kind of level that was relatively ignorable. Now it was everywhere, all the time, demanding my attention. Although, sometimes, moving my jaw could reduce the high-pitched ringing to buzzing.

I went to see another GP. This one sent me to an ear consultant. But before I got to him, I had to see an audiologist. The audiologist was, and continues to be, the only professional I have spoken to who made any sense. In a way she fixed the problem by explaining to me what it was. She did this by telling me a story about wearing a wristwatch.

'You know in the morning when you get up and put on your watch?'

'Yeah.'

'Well, for a second or two you can probably feel it, on your skin, on your wrist. Your brain notices that it's there and checks and says, that's ok, that's just my watch, and then it forgets all about it. So even though your nerves can still feel it, your brain has decided it's not something that it needs to pay attention to, it's not a problem that needs to be monitored or worried about, so it ignores those signals from your skin, it doesn't bother to register the feel of your watch throughout the day, until maybe when you take it off.'

'Ok.'

'So, something similar can go on in your ears. Inside your ears, little electrical impulses are taking place all the time. Sounds. Your brain doesn't bother registering them because they are always there, there's no problem, nothing to worry about. But, with tinnitus, the sound changes and the brain says to itself, hey there's something wrong there, better pay attention to that. And when the brain can find no reason for the noise and no solution to it, it continues to keep checking back to see if the sound is still there and when it hears it is, it's reconfirmed in its alert to something being wrong, and it keeps checking back.'

'So, even if the sound subsides, sometimes the brain can be hearing it as louder and louder if it is still registering it as a problem?'

'Perhaps. But one solution is to break that cycle, to stop the brain listening to the sound. The sound might still be there, but you could teach your brain

to ignore it, the same way it can ignore the feel of your wristwatch.'

She also suggested white noise as a way to break the listening cycle long enough to maybe escape from the sound and stop the brain continually checking back.

I went to see the consultant audiologist after that. He said he could find nothing physically wrong with me and was pretty dismissive of both my anxiety and my symptoms, so I handed over two hundred euros and that was that. None of the professionals I had attended could stop the noise, although they offered solutions to ease the effect it was having on my life. I realised I was going to have to do my best to avoid identifiable triggers that made it worse (jaw clenching, dehydration, anxiety, stress) and somehow teach my brain to ignore whatever noise was left.

I became obsessed with listening to the inner sounds of my body. The idea of electrical impulses that were constantly present but consistently ignored by the brain as 'normal' became fascinating to me. This, I thought, is how human beings make anything difficult or compromising or uncomfortable normal, as long as it is low level enough.

In times of extreme pain or feeling, the brain can actually switch off recognition or experience of it. I think, this is remarkable because it means that there is some way to elevate ourselves above the body, some way to shift what we feel and how much. More than that, there is some way to control our perception of how

our bodies are functioning, maybe even how they work.

There are monks who can melt ice with their body heat, just by sitting there. A doctor might tell you your unidentifiable pain is all in your head. It is, and that is what makes it real.

'Are you worried about something?' my dentist had asked.

'Well, I'm worried about this buzzing in my ears,' I said. 'I'm worried about that.'

The body must be a very noisy place. Babies begin their noise-ignoring lessons in the womb. The womb is the baby's inside and outside space. Newborns who can't sleep love white noise: washing machines, the sound of the car engine. In silence, they are lost. Perhaps, the world outside the body is too quiet, at first, compared to the inside. It is surely overwhelming, this sudden vast silence. This is why they scream when they get out. This is why we sing to them, hold them close to the sound of our heartbeat, our breath, when they get out. The body is home. Maybe the only logical response to suddenly finding yourself outside that safe, body-noise-filled space, is to scream.

When my son is born, he screams. In the months that follow, he screams so loud people who are near him put their hands instinctively over their ears. It is the sound of ten overdue pounds of pure, bodily anguish. It is the sound of ten hours of failed intrave-

nous induction. It is the sound I could not make as I watched the fluorescent ceiling lights pass, fast, flash, flash, flash, as my bed was wheeled from the labour room to a surgical one, and my fear told me to go quiet, not to make a noise in case they knocked me out for panicking. It is the sound of all the feelings that come with paying attention to everything changing and trying to figure out a plan for what will happen next.

The sound in my ears is the sound of blood. The sound at the end of a stethoscope is the sound of blood too. It doesn't matter how anyone else interprets what happens to us. What matters is the stories we tell ourselves afterwards, in order to get on with life.

At counselling, my husband and I talk and listen to each other. You and I are on different frequencies, I tell him. Instead of amplifying each other, we cancel each other out. After we agree the marriage is over, I drive to West Cork to tell my sister, and slowly everyone knows we are going to separate. Months later, she invites me to go with her to a workshop as part of a yoga festival. It's a workshop about making sounds.

Bantry House is a big, old, grand, and beautifully shabby eighteenth-century mansion set in remarkable gardens overlooking the sea. We sit in the main reception room on the floor on our yoga mats, wrapped in blankets and stretchy clothes. I am moving through my life in a cold daze, feeling separate to the world

for much of the time, and so I have not read any of the workshop description. I know nothing about the facilitator. I have just turned up. Turning up feels like all that I can do. It feels like more than enough. I feel brittle inside. I feel small.

I have since lost track of time and many of the events that occurred between 2015 and 2017, which is why I think this workshop took place in 2016, but I might be wrong. I can't find any reference to it online. I can't find the name of the facilitator. I don't remember who else was on the workshop. It's almost as though it never happened, but I know it did, because what I do remember is this.

The facilitator got us into a state of mind where sound had meaning like words do. She got us into a state of body where singing required no lyrics. She made space in the room for feelings without explanation, justification, or reason, and I sang my sadness and pain to my sister, and she heard all of it. She heard me. Without words.

I have heard the sound of the universe. It is everything and nothing. It is a silent scream. It is an endless vacuum. It is pure emptiness and full presence. It is a rage so huge it is beyond noise.

In 2010, I went to the Electric Picnic Festival to do a five-minute talk and afterwards I ended up in a tent with two people giving me a gong bath. I didn't

know what a gong bath was. It's actually a sound bath, clothes on. I lay on a mat. The gong bath givers placed large metal, hanging gongs suspended from wooden structures, at my head, feet, and sides. They moved around, hitting them in turn. I closed my eyes. I became only body. As each one was added, the gongs made a sound that gathered remarkable volume and momentum. I could visualise actual sound waves coming from all four directions, wave-lines merging, colluding, amplifying as they hit a certain looping rhythm. It was mesmerising, obliterating, and eventually so loud and all-encompassing it became a kind of nothingness, an infinite sound without end, repeating in waves that never crashed. It placed me in an intense audio bubble, a vacuum in which I felt unattached to my body, suspended in a sound space of everything and nothing. I was thinking, and alert, but it was as though my mind was floating separate to external things. I became nothing but audio sensation. It felt like inhabiting a primal scream. Feeling it all but feeling safe. A total obliteration of self, coupled with an intense feeling of presence and being. Is this what it's like in a womb?

Eleven years later, it is 2021 and I am hosting live listening sessions over Zoom for the HearSay Festival. We listen to a piece that is shortlisted for a prize. It's called *Baby Talk*, by Lucy Maddox. It begins with the

sound of a woman singing, 'My love for you is a fire in winter, My love for you is a bird in spring ...' It is about being a first-time mum. The baby makes contented baby noises. She is seven and a half months old. 'There is no escape,' says the mum. Then the baby falls, face-plants, and the cries are the cries of a baby anywhere in the world, every baby who ever cried. Afterwards she makes that baby noise of clamping onto a nipple for food.

All babies speak the same language before they have words. It's a language that speaks to our hearts before it hits our heads. This is an intimate, honest piece about pregnancy and becoming a mother. The mum sings and talks about her experience. The words she uses include tumorous, scary, shocked, hard, hysterical, held, love.

Lucy is pregnant on the Zoom call. When we hold the prize-giving ceremony online at the end of the week, she isn't sure if she can make it. Her baby is overdue. The sound of the other woman's baby crying in her piece is still echoing in my ears. We talk about how the pandemic has pulled into sharp focus our understanding of vulnerability, family, connection.

The live listening sessions are intended to compensate for the fact that no one can come to the festival. Instead of gathering in a deconsecrated church, we gather alone, together in separate buildings and individual rooms. So much feeling happens when we listen together, despite the physical distance.

In London, as I am hosting these sessions every day for a week, my youngest sister gives birth to her first baby. Because of travel restrictions, I have not seen her the whole time she has been pregnant. I have not met this baby on the inside, or out. When I do meet her, she is two months old, and she screams in my living room. I think, yes, you make those sounds baby, scream them loud. Those sounds are the truth of your own experience. Make them before the world teaches you not to.

Is the ability to switch off recognition of extreme pain or intense feeling something that we learn or a power of self-preservation we are born with? When my marriage breaks, I think this idea is remarkable because it means we do not have to feel everything if it is too much. But it is not a superpower, it's only a way to get us through the worst part. It cannot be a permanent state of being; at some point, the pain will start making noise again.

There is no such thing as silence unless you are in a vacuum. Sound needs atoms, molecules to vibrate through, something to carry it, at least that's what I always thought. Except, while I was listening to sound waves in a tent in 2010, two scientists in Finland were putting forward an argument that sound can travel in a vacuum, or at least leap across it. *New Scientist* reported, 'Sound can leap across a vacuum after all'.

It is less about whether sound can or does travel, and more about whether there is anyone there to hear it, I think.

After my marriage breaks, I go to the top of a mountain and scream. The wind whips the sound away, disappearing it out of my mouth before it has even hit the air. I scream in the empty house. I scream at the empty house. I yell in the bath. I do it when there is no one here to hear me, and so I am not shouting for help, I am not screaming for attention, I am screaming to myself. I am screaming to get the sound out. I am sending the feelings back into the world as noise. I remember the sounds I made as I laboured through my daughter's birth. I remember the sounds her brother made when he cried. I remember the times in my life when I have screamed at someone. Very few, very seldom and very intense, possessed by the noise, carried by the sound, a conduit for emotion coming from my nervous system, not my head. The volume and the nature of it nothing to do with words.

Human beings don't, can't, exist in a vacuum, in both senses of the word. None of our actions, responses or behaviours do either. Science agrees trauma can travel from mother to womb. We are all part of a long line of nesting dolls whether we have children or not. But a baby in your womb sends something back to you too. It is silent, it is listening, it is waiting, and it has instinctive wisdom we slowly teach it to unlearn.

It is 2021 and I am listening to my teenagers' rage. I am listening to how much of it they let out and how much they hold in. I am trying to un-silence myself. I am paying attention to what I had once thought was silence. Because there is always pain and feeling there is always noise, whether we are hearing it or not.

Sounding

T HE WORLD OF BABIES AND SMALL children is a world
of snot and screams. It is a world of sighing and
growling and excrement and puke. It is not a world of
words. It is about orifices and what comes out of them,
body parts and what goes into them: milk into mouth,
nipple into throat. It is about how much rest can be
stolen from the endless hours of physical presence
required. For a woman who lives by words it is a kind
of death zone, at first.

The language of small-children rearing is a lan-
guage of body and sound. I sang my comfort and my
anguish to my kids. They cried their needs to me. We
moved through space, physically attached, always one
on a hip, always one on my chest, always one in a bed
beside me. In the beginning at least, always one on a

breast. There are no words for these moments, they are contained in themselves. Is motherhood what pulls me back to sound while it also threatens to shut me up, maybe forever?

Can you feel it? That scratch. That scrape. Inside.

After my first cervical smear, some time in my early twenties, I came home and drew a comic strip. It was a simple pencil line drawing. In the first square, what looked like a small chimney brush had just been pushed through the mouth of a glass bottle. You could see it inside. In the second square, it started to twirl in there, using the space to extend its bristles, to gather up whatever it was there to snag: something invisible. In the third, it was gone. Just an empty glass bottle left. See through.

There was no vagina in my cartoon strip, no vulva, no cold metal speculum, no nurse's hand, no spread legs, no image of my scrunched-up face, no deep breath, no held breath, no clenched fist. I drew it because I had no words. The function of violating me in this place is to shut me up, to render me mute.

A smear isn't an attack. It is a pre-negotiated invasion. I submit to it with the understanding that it is necessary, that it is good for me, that it is sanctioned and approved by various professionals as the most sensible way to look after my health. It didn't feel like any of these things. The nurse was polite. She did her job. It felt like a violation.

More than two decades on, I remember the lines I drew. I still don't have easily speak-able words for how it felt, but I can write. I remember the dull-sharp scratching. The internal graunch of implement against wet flesh was something I felt at the back of my throat. Sometimes it takes years to join the dots.

In 2005, I was studying to become a perinatal yoga teacher. I was already qualified to teach Hatha yoga to beginners. I did a workshop in Dublin taught by a calmly inspirational woman who had travelled to be with us from India. I was pregnant with my first child and part of the workshop was about making sounds during birth. The tutor talked about how some women make ooooooooo noises, and others say aaaaaaaaaaaaaa, as their uterus contracts during labour. 'Are you an ooooooo or an aaaaaaaa?' she said, looking around the room.

We were all women. I was the only one who was visibly pregnant.

'This is an interesting and important thing to find out before you give birth, but as many women discover, it is not something they have control of,' she said.

As was the fashion in the early noughties I had written a birth plan, which the consultants referred to as 'birth preferences'. I hadn't thought at all about sounds in labour.

I was sitting cross-legged on a yoga mat as part of

the circle. She caught my eye. 'Come over here and we will test which you are,' she said. Just past the six-month mark, and so big people kept asking if I was due next week, she looked at me. 'We won't do it too strongly, you don't want to induce labour at this stage.' I was here to learn so I submitted myself, and my body, to the demonstration.

She asked me to squat down in front of a chair, resting my head on my arms on the seat. She placed her hands low down in the centre of my spine, just above my tailbone, forefingers and thumb tips touching, near the flat of my back. 'Say oooooooo,' she said. I let out a long oooooo. 'No, nothing,' she said. 'Say aaaaaaaa.' I began a long aaaaaaaaaaaaaaa. It felt good. It felt relaxing. 'Look at that,' she said, as she gathered the other workshop attendees around behind me. 'Can you see that?' Apparently, the shape outlined by her hands on my lower back was expanding. Her fingers were moving further apart, although she was not moving her hands. There was an opening up, a making space. I felt it. She said, 'stop'.

'Now,' she said, 'the cervix and the vagina, are connected to the throat. The cervix is connected to the back of the throat. As you say aaaaaaaaa, you are opening the back of your throat to make the noise, and by extension, you are beginning to relax and open your cervix. This is a useful tool during labour.' I lodged this information away and got on with the rest of the workshop.

My son was big and overdue. More than ten pounds. My body did not want to let him go. He was perfectly comfy inside. He came by emergency C-section because there was no opening up happening after ten hours of induction. When my daughter was born nineteen months later, I had let go of expectations. There was no birth plan except a hope for a VBAC, Vaginal Birth After C-Section.

I don't remember making any noises during the birth of my son. We did play music. It seemed to take up all the space for sound in the room. With my daughter, there was no music and it felt like I sang her out. The midwife kept saying, 'are you sure you want to keep making that noise?' Occasionally, she varied the question with a comment: 'You're going to hurt your throat.' I ignored her. I think what she meant was, you can be heard all down the corridor and none of us really want to have to listen to that noise any longer. Her words made no difference to me. I was in my own place. The noise I was making wasn't a scream or a yell. It wasn't a painful sound. It was a long, sustained aaaaaaaaaa, a tuneful note I found I could hit, a mid-high-pitched note. When my daughter was seven and learning to play the tin whistle, I checked the note, because I can still remember it, and it turns out to be an E. She was born with ten minutes pushing. I didn't get a sore throat.

When it came to my daughter's birth, the connection between the sound and opening was absolute and

explicit to me. The pushing started spontaneously, like an earthquake in my uterus. The midwife told me to stop because I was only 2cm dilated. 'I'm not doing it,' I said. 'It's happening by itself.' She handed me the gas and air. 'Breathe this.' Confused and distracted, I took a puff, but it felt like a ridiculous distraction. The pounding in the middle of my body stopped. But another contraction came and when she checked my cervix she changed her mind. 'Oh,' she said, 'you are two centimetres dilated, but when the contractions come you go to ten. Let's go! Start pushing.' I could not consciously open my cervix, but I could consciously open my throat. I could say I sang my daughter out, but to be honest it felt like she gave birth to herself. I was just with her on the journey, singing aaaaaaaaaa to clear her path.

If voicing a sound can open safe passage, then maybe the opposite is also true. Maybe the function of being attacked or threatened in that internal intimate place can shut the throat down, can shut a woman up?

Women who express opinions on the internet are frequently and quickly slammed down with a very particular type of abuse. You cunt. You slut. Rape threats. The worst of it is aimed very clearly at the genitals. The real meaning of this, it seems to me, and the reason it prevails and persists, is because it is based on an instinctive understanding that to attack a woman

here might serve to render her temporarily mute. The cervix, the genitals, the vaginal passage, these places are connected to the throat. I am choking, I am silenced by the thought of being attacked in this place.

The initial result of my routine smear test was that it deprived me of words. It left me reaching for symbols and shapes, to express an experience so deeply felt, so intense it could not be left unexpressed, but because of the place where I felt violated, wordless. My cervix contracted to protect itself and by extension my throat closed too. No words would come out, so I drew. Perhaps now I could sing about how it felt, abstract notes of invasion and discomfort.

I am interested in the relationship between the vagina and the throat, between the cervix and the voice, and between the very specific use of sexual violence, or the threat of it, as a culturally agreed means of shutting women up. British historian Mary Beard has written about Western society's long history of it. In 2015, BBC Two broadcast a four-part series by Dr Amanda Foreman, called *The Ascent of Woman*. One of the episodes looked at language and featured an interview with the phenomenal Irish actress Fiona Shaw. During the discussion, Shaw said something that pulled some of the thoughts I had been having together: 'vowels hold emotion and consonants hold intellect'. When I tweeted that quote, a speech therapist pointed out that vowel sounds can be sung, that is, vowels can be held as a durational note, and consonants cannot.

This meant my vowel sound aaaaaaaaaa, sung as an E note, back in 2007 as my daughter was preparing to enter the outside world, carried emotion not logic. It opened me up, it caused me to let go of all head-based decisions and become only body and sound. It allowed my baby to be born.

There is no real logic to giving birth. The very mechanics of it are a profoundly extreme proposition. To give birth I had to stop trying to mentally control what was happening, stop using brain-connections, and listen instead to my body. I had to be in my body, which was my baby's body too. And in the body, there are sounds and impulses without words.

That vowels carry emotion and that the conduit and instrument of that emotion is the throat seems obvious when I hear women keening over death or screaming in the face of overwhelming emotional upheaval. Have some men, by being told not to cry from a very young age, and have all of us, by being told not to make sounds but to speak words in order to express ourselves, cut ourselves off from this core, boundary-crossing, universal human language of expression? Songs tell stories even to those who do not understand the words. Sounds cross cultural boundaries to express bodily truth.

Shaw pointed out how the conflict between head and heart is inherent in language, because it is inherent in the difference between vowels and consonants, in the see-saw between emotion and intellect. 'The battle

between thought and feeling is captured even in the word itself,' she said, because every word in the English language needs both vowels and consonants to function. But this idea that the two are in conflict seems to me to be the source of more pain than understanding in human beings. We all contain an inextricable mix of both ways of thinking, processing or just being, even if we learn to trust or prioritise one. True conflict only occurs when we value or dismiss one over the other.

Does this explain the conflict that occurs when a couple with two different approaches to life – one predominantly emotional, the other predominantly logical – clash? Does it explain why the midwife wanted to use a centimetre measure to gauge the progress of my labour, albeit with human fingers, rather than listen to the sound, or trust my body, when it began instinctively to push the baby out? Does it explain why trolls who feel threatened by articulate women on the internet go straight to provoking an emotional response, fear, somewhere deep inside. Is it because they know, instinctively, how difficult it is to find words to fight back when you've been threatened or attacked in that place?

In order to continue to speak or write, women are called on to damp down the emotion and draw on the logical side of themselves. They are called to rally and recall the words they need, even as words begin to evaporate. Foreman introduced her interview with Shaw by saying, 'language is never neutral ... feminine

words are loaded with meaning.' They talk about the words 'feeble', 'weak' and 'king'.

I am parsing out the consonant and vowel portions of words now. Strength. Weakness. Why are emotional responses more frequently described as powerful, when we are taught at school that logical responses get things done? Why is emotion associated with hysteria and loss of control, and intellect or logic with the opposite? All human beings roar, with joy, relief, or pain. Do we accept it more when it is a conquering sound? A win? When women roar in childbirth is it a demonstration of the strength that comes with vulnerability? Every human being feels the need to make some kind of vowel sound when they are pushed to their limits, but often we do not. Often, we shut up.

Perhaps women in childbirth are the cultural inheritors of vowel-sounding as emotional articulation. Perhaps we are the instinctive keepers of this universal language, this wordless expression, this key to opening up. If so, we must never shut up. If so, we are the guardians of this aspect of communication for the whole human race. We have given birth to the whole human race. Most of us have entered the world on a vowel-based note, be it a roar, a scream or a song. After my daughter was born, I wrote nothing for almost a year. Not a diary entry, not a letter, no journalism, no notes. I breastfed and stayed at home, and forgot for a while what I needed words for.

My kids are around seven and six when I go to the GP with a gynaecological problem, strange spotting, unexpected pain. She tells me she'd recommend an STD test. I laugh a little and say, 'But I'm married. The only person I sleep with is my husband. So, you know, there's no point in doing that.' She's younger than me, maybe recently qualified. She keeps all emotion from her professional face and says, 'But it's still a good idea, you know, just to rule everything out.' She's quite insistent. I'm quite sure this is a pointless exercise, but I decide to humour her. Why not? I'm here anyway, and it's not in my nature to say no to doctors.

When I get home, I tell my husband. Good idea, he says. But we only sleep with each other, I say. When is the last time you had one, though? No harm, he says.

I tell him that I'm not even going to ring for the results because it's not relevant to the issue. I never do. I suppose I am presuming that if there is a problem, they will call me. They don't.

Much later, after the text message arrives to tell me he is cheating, I remember something, a conversation we had about another GP, the one who told him, 'You know a vasectomy doesn't protect you against STDs'. And I wonder why he told me that. I wonder about what kinds of conversations go on between men in GP rooms. What kind of things are implied and left unsaid.

It is 2021 and I am divorced. The kids are teenagers now. We are all making new lives. And I hear my babies, who are no longer babies, sing. They sing together, they sing alone, they sing in the shower and in their bedrooms. They sing along to tunes their dad has played them at his house, to tunes I have played them at mine, tunes they found online, tunes their friends have sent them.

I start writing songs, just lyrics. I am writing them for me, but I share them with a musician who is my friend. I say, 'I don't think these are songs because I don't write songs, but these words came out and they seem to be songs.'

'They are songs,' he says.

I write lyrics, but I hear sounds too to go with them, inside my head. I am holding the notes inside. We tell each other we will turn them into songs. We will sing them. We will record them. But we haven't done it yet because every time I try to sing a feeling descends, like a bell jar, not just a barrier to stop my sounds being heard, but a vacuum-like space that will swallow all sound if I make it. Still the words come.

I write songs about betrayal, anger, songs full of feelings contained in words. But I cannot sing them when anyone else is listening. I am silenced by my own body. I am silenced by my own self.

I write,

I prefer a man who puts more butter on my bread
 than jam

A man who holds me up instead of trying to keep me down
Who instead of only if says yes, I believe you can
I prefer a man, I prefer a man

And a chorus to go with it,
I walked the ledge with steep ravines on either side
I couldn't fit into the mould although I tried
I needed space, you needed me kept safe inside
I set you free and at every step you tried
To keep
The strings
Tied

I write slow shanties from the perspective of a woman
who knew,
Perfectly fucking maybe
Perfectly fucking baby
I've suspected it
For quite some time
To be perfectly fucking honest with you

I write a song that begins,
She's not crying cause she's weak
She's crying cause she's strong
Tears of outrage and injustice
(And) because he done her wrong

Don't dismiss her power
Because it seems that she's too high

Feeling small is not the only thing
That makes a person cry

I write lyrics and I hear the words sung in my head, but I cannot sing them. Yet.

It is 2016. I think about my children. I have strong feelings about breaking some kind of cycle. I feel that I cannot stay in this marriage and continue to thrive. I realise my world has been getting smaller since I married their dad, so slowly that I didn't notice. But an unexpected thing happens when I start to say no. I start to say yes too to other things, and slowly my world expands.

A radio producer who lives on the other side of the mountain, across fields and a county border, asks me to work with him on a radio series. We begin by calling it *12 Paintings*. Eventually it becomes a twelve-part series of ten-minute pieces for RTÉ Lyric FM, called *Through the Canvas*.

What neither of us knows as we begin making this radio series is that the shape of the journey from Norah McGuinness' 1962 painting *Garden Green*, which is in the Hugh Lane Gallery collection, to her 1961 canvas *The Startled Bird* in the National Gallery of Ireland will loosely mirror my own escape, my decision to go out again into the world.

McGuinness married a poet in her early twenties,

but after five tumultuous years, the marriage broke down in 1929. She was twenty-eight or twenty-nine. I call up the art historian Ciaran McGonigal who confirms that their 1930 divorce was a scandalous breakup.

Money was running short as news of her divorce hit the newspapers. The artist Mainie Jellett told her to go to Paris. From there she went to India in 1931, and on to London. McGuinness carved out a living by making fashion drawings and drew illustrations for *The Bystander* and *Vogue*. In New York in the late 1930s, she began to design shop window displays, continuing to work for Brown Thomas on her return to Dublin in 1939. She kept painting, she travelled, and she did more commercial work. She also designed sets for theatre, including the first production of *Waiting for Godot* by Samuel Beckett at the Abbey Theatre in Dublin. She didn't marry again.

The radio series starts with me making tea for my co-presenter and producer Diarmuid McIntyre in my kitchen in the house my husband and I have built, a dream house, for us and our kids. This is the home I have told my Galtee Mountain neighbours I will be carried out of in a box. We are blow-ins but we feel we can belong here. I love these mountains, and these fields. I love the valley and the horizon with the Knockmealdowns on the far side. I love the sky and the light, and the way I can see the weather arriving just before it hits. I had planned to stay here forever.

'Milk no sugar,' says Diarmuid. I tell him that I think about the painting *Garden Green* often when I am here in my kitchen. It's a still life painting. There are kitchen items to the fore on a table in front of a window surrounded by roses: potatoes, a spoon, tea towel, cups. Through the window, a woman can be seen outside, moving away from the house.

When Diarmuid opens the heavy sliding doors to the outside, the sound of birdsong explodes. It's the sound of the rest of the world, the world outside the home, the world outside my marriage perhaps. Diarmuid says, 'we are half-way between the domestic world and the wild world here', or does he say, 'wide world'? It's a place I might run to, cross into, in bare feet and dress, like the woman in the painting.

After we finish recording the episode, I tell Diarmuid we have to make this radio series fast. I am leaving the mountain and I won't be coming back.

Sinking

I AM AFRAID OF THE SEA. I am afraid of any large body of water where I cannot touch the bottom with my feet while keeping my head on top. When I was twenty-something my boyfriend and I stayed on a Thai island, which became suddenly difficult to leave because of an impending storm. We had been in no hurry to depart, but as soon as it became uncertain whether or not we could get off the island, securing our exit became an unquestionable, almost frantic necessity. We never talked about staying put.

I remember sitting on the balcony of our wooden chalet reading while he ran down to the pier to check the morning ferry schedule and the availability of tickets. They had suddenly become scarce with the spread of this news by word of mouth among tourists

like us, backpackers. We had no smartphones or easy internet access. Someone had said it to him down at the shop. By evening time, it was already raining.

The light dropped with astonishing speed as I focused on the pages of the book. I had never experienced anything like it. Darker, darker, darker. Until I had to squint, and suddenly, inevitably, but as if without warning, it was too dark to read outdoors anymore.

He came back. He had managed to secure two tickets on a specially scheduled catamaran, which would be able to cope with the predicted waves better than the long-tailed boats most tourists, and we, had arrived on. He didn't tell me, or at least I don't clearly remember, how he got the tickets. Maybe I didn't really want to know. I have a vague feeling someone had to be bribed or persuaded to secure our passage. Was a place skipped in a queue? A lie told to gain sympathy? Cash flashed? An amount of creative ingenuity had been required to make sure we got on that one boat leaving early in the morning from the pier, our last chance to get off the island before the storm really hit.

We got up very early to catch the boat, and walked fast down to the water with rucksacks on our backs, the soles of our feet sliding inside our sandals in the wet. We hadn't slept well. There were other people who wanted to buy our tickets, people who would have bought them from us, even then, last minute, for more than he had paid.

We didn't have an urgent flight to catch. We could

have stayed put and waited for the storm to pass. But my boyfriend liked to be in control, to make things happen, to plan. Not like me, sitting on a balcony, waiting for the storm to hit.

The journey was hellish. Everyone sat below deck in plastic seats in rows facing a television screen high up in the centre of the 'wall'. It was showing *The Fast and the Furious 3* with Thai dubbing and subtitles in English. Or was it with indecipherable dialogue and subtitles in Thai? Or in English, with English subtitles? I can't remember. But I do remember the actor Vin Diesel's face and the cars with the under-chassis lights and the sound of the engines, vrooming and roaring, the yanking of gears, the determined jaws, the speed.

The screen was something to focus on, lights, muscles and fast cars, but it was no distraction from the ceaseless up and down of the boat, the unusual pitch, too steep up, too vertical down, the swell that felt surely too much for this wide two-footed raft with its broad base too full of pale people perched between rucksacks and the smell of vomit and their own fear. No one talked. On the television, competing with the sound of the rain and the sea and the ache of the boat, shiny cars roared and burnt rubber on smooth surfaces in a fictional film world. I don't remember landing or where we went when we got back to the mainland. The journey and the events that preceded it loom larger than anything else.

Around this time, my sister was living in Bangkok with her art college boyfriend, the two of them having graduated in Dublin and gone to teach English to kids. They had a baby together there. My nephew is part of this story, too, because he was three months old and on a boat with his parents somewhere between an island and the mainland off the coast of Thailand as the tsunami was about to hit in December 2004. It killed almost a quarter of a million people in fourteen countries, including 8,000 in Thailand.

My sister wrote us an email afterwards, in which she described the sea becoming strangely still and swelling. She wrote about how when she asked for a life jacket for her baby they told her there were none and so she placed him between her chest and her own buoyancy aid, realising as she did so that if she fell out of the boat there was no way she would be able to hold him in. They were travelling from Koh Kradan to an inlet near a place called Trang. She described arriving at a pier and being met by an open pickup truck, everyone running, and someone throwing their bags onto the back of the open pickup and shouting for them to jump on too and the truck driving at speed away from the harbour as the water began to rise.

They were back in Bangkok, with mobile reception now hit and miss, when our text messages came through. They had no idea of the scale of what had happened. Their escape had just been lucky timing.

A tsunami wave can build low and broad in deep

water before it reaches the coast. It is possible to sit in a boat and be carried on top of this gradual swell without really noticing the enormity of what is building underneath. It is possible to float on top and not understand the signs of what is getting ready to crash when it hits the shore.

My kids know how to make themselves heavy or light when you try to pick them up. They know that muscles can somehow drag down internally and become an ally of gravity or lift up to engage a secret inner buoyancy that lets them rise as they reach for your arms. We all know how to become a deliberate dead weight. Our bodies remember. And we know how to help ourselves float.

One of the first things that happened between me and my boyfriend was that I realised he would not be able to understand that I did not always float. One of the things I realised much later was that when left alone I floated anyway. It was only when reaching for his help that I sank.

The first time we went on holiday together he threw me in the pool. Right into the centre. I remember the feeling. The fear. I couldn't even tread water. I can now. He came in after me when he saw me going down, my head under the water. He dived in and saved me.

'I told you I couldn't swim,' I panted as I caught my breath.

I slowed my heart. Fear followed by relief.

'I didn't think you actually meant it,' he said.

Why would I say it if I didn't mean it? Why would you test it? These are two things I didn't say. 'Well, I can't swim properly. I don't like being out of my depth,' is what I said.

I remember the look on his face. A kind of amazement at the conflux of vulnerability and power, a pivot on the crux of trust. I thought, that was scary, and unexpected. I said, 'thank you for rescuing me.'

The first thing my husband did after he moved out was come back, to shred eight bags of documents in his home office. I know because I counted. The second thing he did was return again to see if we might get back together. I know because I took notes.

Why are you writing things down?

So I can remember what you are saying.

Stop writing things down.

I wrote that down too. I took these notes on two yellow post-its pulled from a block that was sitting on the kitchen counter.

We never talked about what you did wrong in the marriage, he said. We only talked about me.

I wrote that down too. His jaw set.

Later, I thought, we were never in time, never in tune. Always one pulling while the other pushed. We couldn't even sing together. I didn't talk back, then. I

didn't shout. I took notes. Inside, I went silent. I went still. We are all playing out patterns dictated by things buried deep inside, past traumas, unexamined experiences, hurts, things left unseen, things left unsaid. We are all broken in our own ways.

The first thing I did when I found out he'd been cheating was run. Down the corridor. Up the stairs. Into the bedroom. Running to get away. Running because it felt like I'd been shot and if I didn't run a fatal blow might be next. I ran and he did not follow. He must have known on some level that discovery was coming. I hadn't known there was anything to discover and so I was not prepared.

At some point later that day, because I had to sit at my desk and I needed something to look at repeatedly to stop my mind running, I picked a sprig of the red montbretia that came from a cutting from my parents' garden, and which I had planted in the flower beds we built together at our home. The home we built for us and for our kids. We had gardened together here a little, towards the end, making the beds these flowers are in. He drew the shapes and made the plan. He lugged the stones. I fitted them together. I made the walls. Low fortresses, easy to breach, not intended to keep anyone out. The flowers within.

I put the sprig in a blue glass vase I had bought second-hand at the Saturday market in West Cork near where my sister and her family now live. In the weeks that followed, I kept it on my desk and I waited and

watched it wilt. The house was remarkably dry because it was built with a heat recovery system that extracted the moisture out of everything. The building sucked the juice from the stem and the buds, until they became brittle and beautiful. I drew the sprig and sent the drawing to a friend in the post. An un-met package never collected from the post office. No return address. Now lost. I watched it wilt, and by the time it was dead I had a plan. Either this marriage could be saved, or it could not, and if it could not, I would draw a line under this life and start again.

Almost as soon as my husband moved out, I became irresistibly attracted to the action of going places without telling anyone. I put a bag in the boot with a toothbrush and a change of clothes. I became curious about the places where affairs happen. I became fascinated with the idea of keeping secrets.

The first time I went to a hotel room with a man for sex, he brought a red rose with him. It was a cliché I was happy to accept. The whole thing was a cliché. No, it's me, I'm the cliché. The next morning, after he left, I broke the long stem in half to hide the flower in my bag. At home, in my new home, the first place I had ever found, chosen, and lived in by myself, I put the rose in a vase without water and waited. It petrified

as it died, its colour intensifying to a deep rich velvety wine. Its petals blackening to the colour of old blood. Beautiful but dead. Its function was to be a marker of another step away from the me who had ended up in the wrong place and was trying to find her way back to who she was meant to be.

I have discovered that I feel safest when I am by myself. It turns out this might have been true for as long as I can remember. I spent some of the happiest days of my childhood climbing trees, sitting by the river, scrambling through hedgerows, by myself.

In 2021, three years divorced now and making a life that's my own, I write a poem and record it on my phone and send it by email to be played from a speaker hanging from a tree in a wood in Scotland. Galloway Forest Park is a Dark Skies Park. It's one of the darkest places there is.

This poem is meant to be heard, to be voiced as it gathers momentum. It's meant to build on itself as it accumulates, and so the lines repeat:

Forest Memories for the Lone Women in Flashes of Wilderness project

I am eating sorrel in the woods; I am eating hazelnuts.
 I am eating wild strawberries.
I am eating sorrel in the woods; I am eating hazelnuts.
 I am eating wild strawberries.
I am walking on moss; I am testing a branch. I'm
 checking to see if the ground will hold me.
I am walking on moss; I am testing a branch. I'm
 checking to see if the ground will hold me.
I am touching a rock; I am feeling the bark. I am
 listening, looking, feeling.

I walk in the woods. I know every path. I look to find
 ones that are hidden.
I walk in the woods. I know every path. I look to find
 ones that are hidden.
I hide in the branches; I hide in the ditch. I look into,
 around, and over.
I hide in the branches; I hide in the ditch. I look into,
 around, and over.
I am here in the woods; I am feeling the bark. I am
 listening, looking, feeling.

I know my way home; I don't need to go there. I have
 all that I need all around me.
I know my way home; I don't need to go there. I have

all that I need all around me.

I am eating the leaves; I am eating the nuts; I am
eating the berries and bounty.

I am eating the leaves; I am eating the nuts; I am
eating the berries and bounty.

I am here in my heart; I am here in my home. I am
safe with the woods all around me.

I can hide in the woods; I can find all I need. I am
safe with the woods all around me.

I can hide in the woods; I can find all I need. I am
safe with the woods all around me.

I don't need to go home, but I know it is there and I
know if I hide, they can't find me.

I don't need to go home, but I know it is there and I
know if I hide, they can't find me.

I am here in the woods; I am here in my heart. I have
all that I need all around me.

Lone Women in Flashes of Wilderness is a collabo-
rative project that invites women's thoughts on, and
experiences of, aloneness, darkness, and wilderness.
After the sounds are played in the forest, the project
originator Clare Archibald sends twenty-four samples
of the 140 audio contributions to an online radio show
called *Experimental Trash*. I listen to this new mix,
made for radio, and I hear how scared many women
are of this wild, untamed place: the woods. I hear how

it is not necessarily the woods they are scared of, but what they might find there, or what might find them. Why do I feel safer when I am alone? Even in a dark forest, perhaps especially in one, I feel safe. On the side of the Galtee Mountains, 600 feet above sea level with only sky and trees, rock and grass, fraochans and cobwebs, running river water, insects, birds and three domestic cats for company, after my marriage breaks, I feel safe in nature, outside, alone.

The world is a year and a half into a global pandemic. It's more than five years since I handed my phone to my husband with that text message open, looked at his face, and ran. I think I am still running. Maybe I've been running my whole life. I used to keep a tiny red suitcase under my bed when I was a kid, filled with the possibility of the notion of running away. Not from anything in particular, or anything I can remember. But I'm paying more attention to thresholds these days, transitions between places and states of being. Inside, outside. Movement, stillness. Thinking, feeling. Silence, speech.

I spent much of my childhood living next to a river. Our home from when I was six until I was fifteen, the 200-year-old farmhouse in Kilkenny, was called Riverhouse. There is a painting of me, sitting on a

rock in the middle of this river, in the townland of Ardra, my floral cotton dress hitched up, long, light brown hair hanging down, my toes dipping. This is one of the happiest places I have ever been. The oil painting is by my mum, and it is unfinished. It's based on a photograph I don't remember being taken. The sun is shining. The foliage is green. The water is cool. The girl is alone, and she is utterly content. There is nowhere to go, there is only the river, only her toes, only the sound and the cold of the water, only air, sky, leaves, rock. And skin touching those things. Her skin is the line between her and the world, the edges of her, the way she meets it.

It is 2017. I am making the radio series. The first episode is to be recorded in the house I will soon be leaving forever. It's the house we built together in the middle of a wilderness, on the edge of three county borders, on the side of a mountain.

I publish an article online to go with the second last episode. I write, 'The Northern Irish artist William McKeown (1962–2011) made the kind of paintings I want to inhale.' I write, that when I first saw McKeown's work in the Douglas Hyde Gallery in 2001, 'It gave me the most profound sensation of coming home to myself.' I write that McKeown made near monochrome paintings that can be read as patches of sky, that he made a series called *Hope Paintings*, and a series called

Forever Paintings. I write that in 2010, he made a series of black paintings called *Tomorrow.* The following year, he was found dead in his apartment. He was forty-nine. I write, 'This was a world I knew from childhood and … an artist who captured so absolutely that sense of insignificance and utter connectedness.'

Tomorrow isn't always promised.

The eleventh episode of *Through the Canvas* begins with bee and bird sounds. We are lying in a graveyard looking at the sky. We are talking about a McKeown Hope painting, called *Hope Painting, Through the Looking Glass* (2005) in the Irish Museum of Modern Art Collection.

I feel safe in nature. I feel safe in art. They both contain beginnings and ends. They both take me in and out. They both take me to the edge of my heart.

Next to the churchyard the River Bride flows, and there are children jumping in. We spend some time trying to record the sound of my body crossing from the surface to underneath the water. Only a few seconds of this audio makes it into the radio edit. What is curious is that I cannot make myself heavy enough to stay under. Every time I try, I start to float, and the river begins to take me away.

McKeown's work is one of the reasons I've persisted as an art critic. In 2000, I was the editor of an arts and culture website for the Irish national broadcaster RTÉ. The core team was made up of twenty-somethings and recent graduates with a mix of graphic design, HTML,

and journalism qualifications, and ambitious inter-net dreams. Our offices were in portacabins near the nineteenth-century Montrose House on the grounds of the TV and radio station. We were predominantly pre-marriage, pre-kids, and so we often stayed late, working to get articles finished, working to publish new material to the website.

My line manager walked in one evening. He was married with kids. It was late. He asked me what I was still doing there.

'Just finishing this exhibition review,' I told him. I wanted to put it up before I left.

'You don't have to do that,' he said.

'But I do,' I said.

The visual arts section of the website was about to get the chop. I was trying to preserve it. Ultimately, I would fail in this ambition.

It's a review of William McKeown's 2001 exhibition at the Douglas Hyde Gallery in Dublin, called In an Open Room. It is not a particularly well written review, but the art is important, and so I do it. I leave this job two years later, with my first piece as a freelance art critic published in *The Sunday Times* the week before I finished. I got the gig by sending in samples of art writing I had done against the odds, including the McKeown piece. It was a leap into the unknown, without a life jacket.

McKeown's work got frequently darker. When he died at his home in Edinburgh in 2011, he had been making

some of the best, most inspiring, most heart-breaking work of his career, and yet he was sinking. A year after his sudden death, I review a tribute show, 'Visions of Infinity' at the Kerlin Gallery in Dublin for *The Sunday Times*, and I try to capture some of what McKeown's art contained without words, in words.

> Sometimes art can make you want to disappear. Not in a bad way. Sometimes, standing in front of a painting can remind you so overwhelmingly of the way in which we are all part of a bigger whole that it seems to offer the possibility of a kind of painless expiration, an embrace that might simply absorb you, not into obliteration, but into everything. It is rare, but sometimes art can remind you of your own insignificance without making you feel at all small. William McKeown's art did that.

McKeown drew rural wildflowers in coloured pencil, which he exhibited alongside his paintings. The pale yellow seeping into white pigment like an extract from the centre of a daisy dissolved. I write, 'Apparently he did not intend his subtly graded monochromes to be transcendental, but they were.'

I write, 'His paintings offered not just the gift of hope but the double-edged promise of escape.'

'I wanted to focus on a moment where surface dissolves,' said McKeown in 1997, 'where the appearance of what is seen encounters the invisibility of what is sensed.'

I write, 'When he spoke about the space he was trying to paint, he said "you can't really do it – you can't represent that space. It only happens in the head. You can only feel."'

I write, 'I think he was wrong. You can do it. He did do it. He did it in such a way that we felt it too.'

McKeown painted how profoundly overwhelmed we can be by deep feeling, the membrane between calm and panic, silence and noise, dark and light, the surface of the water and what is underneath, breathing and not. Five years later, I tell my radio co-presenter these paintings are about thresholds.

In an earlier episode of *Through the Canvas* we went to Kilkee on the west coast to talk about a watercolour sketch by Nathaniel Hone the Younger in the National Gallery of Ireland Collection, *Waves Breaking on the Rocks*, painted in 1890. It's a stormy, windy, wet day. Waves are crashing. We stand on the rocks at Kilkee. We go up to the cliff. I am terrified the wind will take me, the waves will swallow me. But they don't. None of that makes it into the radio programme.

We meet a fellow walker who tells us how the sea is a place to feel alone but not lonely. We walk out on the rocks. This fellow walker talks about how the Pollock Holes here, locally numbered 1, 2, and 3, are for swimming. They are natural rock pools you can swim in when the tide is out. He talks about how children don't

like Pollock Hole 3. Too deep, too seldom uncovered by the tide, too close to the edge.

I think I will always be someone who feels safer in a forest, up a tree, up a mountain, by a river, rather than next to, in or on the sea. I think I will always be afraid of bottomless depths, of the potential for all-obliterating waves. There are artists who paint the sea, artists who paint the sky, artists who paint the ground. There are artists who paint the places where air, water, land meet, and the thresholds in between. I think about the painter Tom Climent's weighty, floating, shimmering mountains and the artist Sean Hillen's paper-collaged landscapes driven by visual glitches.

I think, the gaps between us lie in the gap between emotions expressed and emotions hidden. I think about the distance between thoughts given shape and thrown out without fear or judgement, and thoughts held in to the self and yet somehow also held against another person, even though they remain fugitive, formless. Strangely these thoughts gain more power when unspoken. They grow even though they never come into the light to reveal themselves in all their gloried human flaw.

In 2015, I am writing about the work of the artist Gerda Frömel. She came to Ireland in 1956, recently married, in her mid-twenties. She was born in Czechoslovakia and educated in Germany. She came with

her sculptor husband and young son. By the age of forty-four, she was gone, drowned on a summer day off the coast of Mayo while going to help one of her sons, who survived.

Forty years after her death, the Irish Museum of Modern Art opens a retrospective of her work. It is the year of the counselling my husband and I are doing to save our marriage. I write in *The Sunday Times*, 'Drowning, death, marriage breakdown. There is such an air of tragedy about the superb Gerda Frömel retrospective at the Irish Museum of Modern Art.'

Frömel's two-year-old daughter Natasha drowned in a small trough in their greenhouse in Dublin in 1959. Three more brothers this little girl would never meet were born in 1960, 1962 and 1964.

I write,

History has recorded Frömel as a sculptor, but her pencil drawings are one of the great revelations of this show. A scratch-mark pencil-jab composition forms a human silhouette. A faceless form emerges from a series of pencil dots with tails. Elongated human bodies are made from a few deliberately scribbled lines. They're all untitled and all driven by a kind of mindful spontaneity. Several functioned as preparatory drawings for sculptures but they are artworks in their own right and Frömel exhibited them as such.

I write,

Some of the pieces here are primal hunks of weighty

metal, but at this time she also made works so delicate they remain only in black and white photographs ... One is here: Deer on Rock (1965), in which a miniature animal barely staggers on wire legs across a hunk of granite landscape. It's a fragile figure in a dramatic, hostile world. One of the only surviving ephemeral works from the 1960s, it feels like a privilege to see it.

Frömel's husband left in 1967. By 1970 the marriage was over. Five years later, Frömel was dead. I write about the bronze figures of Eve and Ondine that appear at the end of the show. I write that these sculptures produced in Frömel's final years are the tragic triumph of the show.

In my unpublished notes I write,

Her 1973 Spear *is both like an arrow and a shield as well as a spear and the shape of a musical instrument, which is also the shape of a woman. A two-metre-tall steel form on a rectangular marble base.*

I write,

Later versions of the Eve figure were given the title Ondine, a water sprite doomed to die if her lover was unfaithful.

Frömel makes mostly abstract work. In my published review, I write,

In Christian narrative, Eve is the woman doomed by her body to take eternal responsibility for the fall of man. Ondine was a mythical water sprite doomed to die

if her human husband was unfaithful. She was said to take beautiful children into the sea. *Frömel's Eve* (1973) is both a body and a weapon, a spear woman. This is the room in which you realise that the blades and spears in Frömel's work are women too, with abstracted waists, hips and bust.

Woman as body and weapon.

I think about her infant daughter who drowned in an accident at home. I write, 'for an artist, what life throws at you is never as important as what you do with it.'

The images in this retrospective exhibition stay with me. They are images I have seen and images I have not: steel blades, bronze women, marble heads; a single mum aged forty-four swimming with her kids.

Breaking

THE GREAT TRAGEDY OF ENGAGING IN a Collaborative Family Law process to undo a marriage is that, in order to succeed, it requires you both to behave like, if not become, someone the other could have stayed married to. It requires you to collaborate.

A friend describes separation as a storm you have to go through to get to the other side. I decide childbirth is a better analogy. With a storm you can wait it out, maybe go around it, find a different route. You could maybe even change your mind about where you are going. With childbirth there is no better time, no other journey, and the destination is non-negotiable. The analogy works better too for two people who once saw their lives as travelling in parallel, a team. In a successful Collaborative Law process, both want

the same outcome, both want to get there as safely as possible, both want the outcome to be healthy and robust enough to survive into the future, especially, and perhaps only particularly, if you have kids together. The children are what keep you attempting to harmonise, even as you grow increasingly out of tune as you move apart.

I had thought that marriage was a kind of security. I had really thought that it was somehow fixed, in the way fixative spray holds pigment to a surface, or kiln-fired clay holds its shape. I was wrong. People look for a one-word answer for why it broke. But one word is never sufficient to describe a complex human situation, and infidelity alone is not always the end of a marriage. In the end, the end is more complicated, certainly more so than the beginning.

He kissed me in the rain in a car park when I was crying about another boy. That was probably not a good start. I had grown up with the idea of marriage as a happy ending. In undoing my own I discovered I had held my life to standards I did not expect, or even admire, in the lives of others. Marriage is not an end point. It is not a destination any more than other major life events or even goals. Marriage is ever shifting and evolving, just like the people in it. Marriage is not fixed. And ours couldn't be in the end.

After our year of couples' counselling, we had done more talking and knew each other better than we ever had in eleven and a half years of marriage. The rela-

tionship lasted almost twenty years from car park kiss to the heavy hug we shared at the top of the steps that led to the front door of the place he rented when he moved out. At that point we were still, oddly, friends. And still it was over.

Failure is a measure of expectation. It is never some kind of absolute. Back when I was hopeful of the kind of revelation our facilitator and legal team had talked about as being the pivot on which all Collaborative Law successes must turn, I believed the ah-ha moment would be some kind of mutual one, a moment when both of us saw the potential for a new truth. This new honesty between us would be based not on a narrative so deeply held and rooted it was impossible to pull up or transplant, but on a mutual letting go that would allow the story of us to grow in a different direction. I believed in change, hope, transformation. Some occurred. It wasn't enough. The Collaborative Family Law process lasted about a year before it too failed.

Expectation is an essential ingredient of marriage. Because marriage is a contract. It stipulates certain measures by which we deem it to have succeeded. Loyalty, honesty, respect. These are among the expectations. Infidelity does not have to be the end. In a significant number of marriages, it isn't. But then again, many feel they have no option but to stay married. Because principles like loyalty, honesty, respect can be cast aside if they are outweighed by the reality of

financial dependence, children, motherhood: career progression traded for an old-fashioned notion of the best family structure.

The first referendum I voted in was the Irish Divorce Referendum of 1995. A similar proposal to remove the ban on divorce from the Irish Constitution had been rejected in a referendum when I was ten. Imagine if the 1995 amendment had not passed. I'd still be married. An un-undoable mistake.

I had sleep-walked myself into a situation where, as the primary carer for our two kids, my financial independence had slowly ebbed away. A woman who has lost her financial autonomy does not have the luxury of trading a lack of loyalty, honesty and respect for freedom. She may find she is not in a position to choose independence over security for her kids. Stay together for the kids. Stay quiet for the kids. Children are a useful weapon for silencing betrayed spouses, betrayed women in particular. Preserving public reputation of the main breadwinner is a useful weapon for shutting betrayed spouses up. And there is a weird societal requirement to preserve face, to keep everything going, so that even though everything has fallen apart behind closed doors, it all looks like it is still standing from the front.

I write a piece of flash fiction about a slow seep of toxic normality. It's called 'Poison in the Dinner'. I don't send it anywhere for consideration.

She takes a deep breath. In a marriage you split respon-
sibilities, your Honour. Just because one party knows
how to use the washing machine and the other does not,
does not make one party stupid. Just because one party
understands how to fix the lawn mower, does not make
the other party incapable or ignorant. It means the pair
have divided responsibilities, your Honour. It means they
have delegated some of the tasks of living to each other
and have thankfully switched off that particular worry
or concern, handed it over. It does not make anyone
stupid or incapable. It is one of the great advantages of
pairing up, the division of the daily tasks of the practical
practicalities of living.

There is silence in the courtroom. She inhales and
exhales and begins again. If one party is responsible for
the money, it is not stupid. It is trust. You don't expect
your husband to put poison in the dinner, you don't stand
over him asking about and reading the label on every
ingredient, because you don't expect your husband to
put poison in the dinner, just as he does not expect you
to spray insecticide on his toothbrush, to hide needles in
the cake you baked for your children's party. Because that
is marriage. Because that is trust. And it may appear
stupid, but it is only stupid if the person you have cho-
sen to love and make your usefully shared life with is a
person you should not trust. And who would marry a
person they did not trust?

Your Honour, it is nothing to do with wilful blindness,
with stupidity, with ignorance. It is everything to do

*with love and trust. That is marriage. That is why I am
standing here. You don't expect your husband, you trust
your husband not, to put poison in the dinner.*

A legal process, a separation agreement, a judge, a
court, a set of solicitors going back and forth over two
desired outcomes for one story can never give you what
you want, which is always, in the end, for the other
person to not be who they have turned out to be. The
revelation comes when you realise the only person you
have the power to transform is yourself. And that then
becomes a new measure of success.

It is early 2018. I tell the facilitator, just because
I'm crying doesn't mean I'm not strong. She nods. I
tell her, I'm not scared. But I was. The collaborative
separation process has floundered and stopped. I write
a note to myself,

*Ending a marriage shouldn't be like dragging a reluc-
tant baby backwards through a reverse birth. Or then,
maybe it should. The two children that got us here, the
house we built, are all part of this. Part of what must be
dismantled, salvaged, risen from. We are taking the life
we made and unknotting it, some parts slipping asunder
like they were never properly tied, others so stuck the
only solution may be to cut. What is lost in the cutting
is only partially seen. What is lost in all of the undoing
is the energy that went into tying the knots. Knitting the
yarn sewing the threads into a shape we thought we had
made whole and too tough to yield to unravelling. But*

it wasn't and it's not. And there are many reasons why this garment we wove no longer fits.

The energy that comes with the adrenaline from this stressful, unpredictable time does not disappear. It gathers in the corners of rooms and the angles of elbows, waiting. It applies itself to endless scrutiny of locks and doors. Window catches are shaken repeatedly. Inside becomes a trap and a refuge. I loop inside the house. Where to now that my home is no longer safe for my heart?

People say strange things to you when your marriage ends. Lots of them want to tell you how theirs nearly did too, but not actually tell you because if anyone knows then it's over. That's the first rule of a marriage in crisis, apparently. Don't talk.

At the school gate one of the mums comes up to me, six months later. I only just heard, she says. I only heard at the lunch in the hotel after the communion. I just wanted to say, and not not say it, you know. I did know. I was glad really that she had. I didn't know at the church, she said. I had no idea. But then at lunch they said did you hear and I said no. No, I said. No way. I waited. Sunglasses on.

Anyway I wanted straight away to drive up to you, she said. I have this bottle of champagne in the fridge and I wanted to drive up to you some evening and we'd

drink it. I don't know what we'd be celebrating but I thought of you and I thought I'll drive up to her with that champagne.

I said yes, do. Although she never did. And I'm not surprised. I was like a woman with barriers up. I was not at the champagne drinking stage. And she started to talk about marriage. Cooking a steak and leaving it in the kitchen, eating pasta alone on the bed. The things that go on behind closed doors. Marriage, I said. You just never know.

When nobody knows your marriage is broken, peripheral people tell you you look amazing. They compliment you on your sudden weight-loss and mistake dark glasses for glamour. Afterwards, when they know, the same voices tell you you're looking very skinny, and seek out your eyes for signs of tears. The secret is to fix it or end it before it goes too far. To end it or fix it before the weight loss gets out of control, before people start saying to each other, 'Is she eating properly, I wonder?' No one says, 'Are you eating properly?' directly to you. The people who know you better, who are slightly worried about you but not sure whether to trust their instincts, because you're hiding it so well, don't know what to say, so they say nothing. You find out later that these are the people who love you.

For two years, I weigh myself every day. I am not hungry, so I am observing the fall in my weight with

a kind of distanced curiosity, but it is also pleasing. I go on dates and I know I am sexy because I am thin. We have separated but we take one last family holiday. This is a mistake, but I lie in a bikini and know that I am sexy even though my husband does not want me, because I am thin. But there is something else too, something more powerful than that thin message about worth and value which really comes from outside. Inside, I am trying to disappear. I know the smaller I am the less space I will take up. The less of me there is to feel pain. The less visible I will be. I am sick of the size and volume of the feelings inside myself. I am trying to shrink them, trying to shut them down. They are too much. What I want is to slowly cease to exist.

It is so very odd and so very ordinary for me to have looked for role models. It is so very surprising how my perception of these women and how they apparently fixed their marriages has changed, now that I have not fixed mine. Posh and Becks, I said to myself, their relationship survived infidelity. They made it work. They had more kids. But in waiting rooms, I look at paparazzi shots of Victoria in old magazines trying to cheer myself up and I remember that she never smiles in public. Does she laugh in private? I turn a page to find a story about how she is removing her tattoo, slowly lazering one inch at a time, in a vertical line up the top of her spine: I am my beloved's and my beloved is mine, it says in Chinese lettering, apparently. The magazine speculates with gleeful dread about a rift.

Nobody knows what goes on in a marriage except the two people in it. Various people repeat this to me now that they know. It occurs to me that if someone else does know what exactly is going on in a marriage then the marriage is probably in trouble. Because the one thing I knew was that the fewer people who knew about what had gone wrong, the easier it would be to stay if it turned out we could fix it.

I am looking for role models, for women who can show me how it was done, how they held their families together. I am realising I don't know any women like this because no one talks about this, no one tells anyone about this, about staying in a marriage that is broken. Family is something worth saving, but there is also a time to walk away.

My aunt said to me, 'I don't know a single man who hasn't done this'. She means cheated on a partner, I guess. I nod, resigned to the clear inevitability of her uncompromising truth. Later, I think, maybe she's just been unlucky in the men that she's known in her sixty-something years. But I believe her. I am broken and something in me made her speak. Is she tired of saying nothing? Is she tired of hiding the truth? Is this the big secret generations of women have kept from each other, the secret of what they put up with for family? The compromises they made, the forgiveness they forged, the heartbreak they hid, even from themselves.

I can feel the weight of the mistakes of past generations pressing on me, in a wordless, inexplicable way.

I can feel layers of people in my past, with stories of their own. I tell her I am ending this marriage as much for my children as I am for myself, not because there is fighting, not because what has happened can't be hidden from them, but so that I at least don't keep repeating some age-old pattern, so with me at least it stops somewhere. She says, with more force than I've ever heard her use before, 'Oh, good for you Cristín. Good for you!' And we sit there in the silence that follows. 'This is freedom,' she says.

When your marriage is suddenly shattered, you need four things and each of them is a friend: one who will offer you a bed and a key to her house saying arrive any time, any day, any night, and call it home; one who will cry with you at the kitchen table and hold your hand at the shock of it all; one who will deliver home-made soul food when you are alone and not eating; and one who will take you shopping for the biggest pair of sunglasses you've ever owned. You're going to need them at the school gate, even in November. 'Nice sunglasses,' they will say. 'Thanks,' I will nod, not taking them off. I will wait until the last minute to exit the car and look for the kids, bundle them into their seats. I used to have casual friends at the school gate, but there is no room in me now for flippant friendliness. If it wasn't for the school run, there are many days I might not get out of bed.

'At least you're not Cheryl Cole!' laughs a friend. You need friends to make you laugh too. Poor Cheryl.

She got very skinny. Cole isn't even her name. It's her second last married name. We talk about women and marriage and surnames, and changing them back. Hey, there's Beyoncé. She's got a surname, but she hardly needs it. She also made the odd move to reaffirm her husband's status by calling her post-marriage concert series the Mrs Carter tour. That tells you a lot about male insecurity and female pandering. But did you know, Beyoncé is a surname. It's her mum's surname.

I think I'm only looking around at celebrity stories as a distraction from my pain, but it's also because no one in Ireland talks about infidelity unless it's a public story and that only happens with celebrities, and mostly they are stories from far away, stories that are far removed from our lives. Marriage in Ireland is so sacrosanct, what happens inside it so secret, no one else's business. When I first got married, someone repeated to me a phrase I'd never heard before. She said her mum told her on her wedding day, 'What happens in a marriage stays in a marriage'. Really? Celebrity stories are safe because, in Ireland, divorces are failures that happen to other people. And not least because of the insatiable, ingrained misogyny the Irish state was founded on, his infidelity somehow feels like it's your fault. The woman is meant to hold it together, regardless. The woman is meant to make herself better, to change her shape to keep him. The woman is meant to keep the marriage afloat.

My experience has coloured my perception of all

relationships. Everywhere I look I see what feels like a power play, everywhere I look every relationship, every marriage, feels fake. And then Beyoncé releases her *Lemonade* album in 2016 and I don't admire her for sticking with her cheating man, but I do admire the way in which she makes a statement that the best bid for survival is to create, to be loud, to express pain, to look to your ancestors and the wisdom of women who came before, because they've been there too.

Something breaks in me: a silence barrier, a sound barrier, a barrier with words. I decide a biography of an artist I've been working on quietly with a journalistic approach actually needs to be a work of historical fiction. I go to the Tyrone Guthrie Centre to work on this book in 2017. I lay it out on the ground, and it begins to take shape. The shape is dictated by colours, and by ten months of the year from November 1925 to August 1926. I get an email from Kevin Barry, one of the editors at the *Winter Papers* anthology. He is looking for a short story. Someone has told him I might have a story. I have a story I have been keeping for two years, not because it's not finished, but because I thought it had nowhere to go. He publishes it. It's called 'Yes, I said Yes', and it captures some of the surreality of being broken and feeling trapped in a domestic relationship.

And now something is broken, in a really good way, in me. A line has been crossed. I find a book at the

Tyrone Guthrie Centre by Leland Bardwell. It's her 2008 memoir *A Restless Life*. The introductory page includes three quotes:

> 'Nothing I write is as true as my fiction.' – Nadine Gordimer
> 'Tell all the truth but at a slant.' – Emily Dickinson
> 'If I hadn't been a writer I'd have been a good housewife.' – Anaïs Nin

That last one in particular feels like a mantra for me. I am not a very good housewife.

I find a copy of *The Bell* by Iris Murdoch, her fourth novel, written in 1958. It's a book I also have at home. The opening lines read: 'Dora Greenfield left her husband because she was afraid of him. She decided six months later to return to him for the same reason.' There are very few new stories about human beings on this earth.

I start to say yes to private commissions from artists to write about their work. This is not journalism. This is not marketing copy. This is not art criticism even. I say, I will only do this if you let me write what I want to write, and the artists say yes. In these essays I find space for a more immediately personal response. I put myself into the work in a way I was taught not to do as a journalist when I first started out. There is more of me in the visible words and less of me in the gaps.

I write a piece called 'Past Portals to the Future', about Siobhán McDonald's work:

The morning after I visit the artist Siobhán McDonald in her studio, a headline appears in my Twitter feed: *Repeated Radio Signals Are Coming From A Galaxy 1.5 Billion Light Years Away.* It's a story about how scientists have found 'repeated blasts of radio signals coming from deep in space'. 'The flashes only last for a millisecond,' writes the author, 'but they are flung out with the same amount of energy the sun takes twelve months to produce.' It's the 9th of January 2019, and while I am reading this in Cork, McDonald is in Dublin working on new pieces for her Limerick City Gallery Show. The materials she's using are charcoal and gold.

This shift in my writing becomes more deliberate as the worldwide pandemic hits and everyone's relationship with media, culture and art, changes as lockdowns separate us physically and technology connects us virtually. I write about Tom Climent's new series of works, *Everlast*:

My visit to his Cork studio is the last 'social' encounter I have before Ireland begins its Coronavirus lockdown. The start of 2020 is a strange time, here and everywhere. As we speak, a global anxiety is looming, something big and bad is coming for us all. And yet, here are Climent's paintings, which despite their rainbow colours, are deeply rooted in an understanding of the dark.

By the time I am commissioned to write about Abigail O'Brien's work for the Highlanes Gallery, the style is immediate, untrammelled. I write,

> The work of Abigail O'Brien has always felt, to me, heavy with silence. When I was in my twenties, it made me uncomfortable. It was weighty with things left unsaid. There was portent in the still, emotionless images of women sewing, cooking, working together and yet seeming so alone; in domestic settings, enacting daily rituals, taking part in religious celebrations.

Three months into the pandemic, I am commissioned to write something about art in response to the theme of walking in James Joyce's novel *Ulysses*, for the RTÉ Arts and Culture 2020 Bloomsday celebration, alongside the authors Mary Costello, Ian Maleney, Joseph O'Connor, and Nuala O'Connor. I write a piece called 'Stopping to Kiss'. It begins,

> Three of my lifetime's first kisses to date took place as we walked, or rather in places we stopped as we walked: standing beneath the rustle and shelter of on overhanging hedge; on a city river quayside, against the cold, dark, stone; in a car park, both drenched with rain.
>
> When I think about couples walking, I think about first kisses, and holding hands, but also this: when we walk we talk, and when we walk and talk, we speak of different things to the kinds of things we say out loud when we are face to face. Stopping to kiss is a punctuation in the conversation that happens when

two people are moving forwards, getting to know each other, propelled by the rhythmic motion of feet, walking companionably perhaps into a life together.

In 2021, the curator Dermot Browne asks me to write a response to two exhibitions that take place in Macroom Town Hall in County Cork. I write a piece called 'Thresh/Hold'. It begins with an epithet of three definitions.

Thresh: to separate grain or seed from a harvested plant; to move violently, thrash; to repeatedly strike.

Hold: to grasp, carry, or support with one's hands; to keep or detain; an act or manner of grasping something; a grip.

Threshold: a strip of wood or stone forming the bottom of a doorway and crossed in entering a house or room; the level or point at which you start to experience something, or at which something starts to happen.

I write,

The threshold exists in the gap. The threshold offers a gate. The action of crossing from one place to another

is an act of separation, an act of violence, in that it involves necessary change. Passing from one state to another demands that we find ways to hold on, get a grip. Safe passage is a leap of trust. To get through, we must make a journey of faith: not to get lost, or stuck, in the gap. This almost invisible work happens in the in-between space. We learn to do this threshold labour often mindlessly, because we must do it so many times in our lives. We become immune to the toil. We forget to notice, dismiss the impact of the crossing, because we must traverse the gap in order to reach the other side.

I write,

Grief is also a gap. After her brother Jerome died, the artist Miriam O'Connor returned to her family's farm in County Cork. The art she made there, as she joined her mother and sister in the endless labour of carrying on, formed the second Macroom Summer 2021 show, Tomorrow is Sunday. O'Connor takes photographs, but she works with words too: stories, lists, inventories, letters, logs, notes. Her exhibition is full of unanswered, unanswerable questions. *What time do cows go to sleep? Where on earth is the key to the tractor? What happened to the dog?* And the ones we come up with ourselves: What happened to the cat?

I write,

The pandemic left us with an aching awareness of

the gaping obviousness of what is important, and what is not.

I write,

> What is important? Human connection, the land, what we make with our hands, what we feel with our heart, what we say with words, what we build with our lives. What is necessary resilience? It's something to do with moving forward while staying put. Maybe in the gap we are not lost, but can find ourselves, if we take a moment to stop? What wisdom is to be found in the in-between space? How do we thresh while we hold?

I have been threshing and holding for years now.

When I was twenty, I was waiting at a bus stop on my own one day. A car pulled up offering me a lift. It was someone I had recently met, and he was travelling in my direction, so I got in of course. Years later, he told me he was actually on his way home when he saw me there. He was travelling in the opposite direction, but he turned the car around to offer me a lift because he wanted to spend time with me. He wanted to pick me up. A gesture of chivalry wrapped in a lie. And I said yes. Never say yes to a man who doesn't want no for an answer.

It is 2015. I go to see a therapist. She listens and then she looks at me and says, 'Your heart is broken.' I think no, no, my marriage is broken. I am broken. My heart cannot be broken. My heart? I don't go back to see her again.

History doesn't record heartbreak as an event. It doesn't record the moment you find the text message, the receipts, or the photo. It might record the facts, the divorce, the names of the people involved, but it doesn't record the moment when the whole world shatters, the moment when you know for the first time, and all the things you didn't see and all the words you didn't hear up until that point begin to pulse and throb. Memories of a mobile phone quickly snatched and switched to silent, phone calls not answered, travel plans kept loose until the last minute, meetings that ran on, a new move in the bedroom, a distracted kiss. All of that becomes a new history inside your head but not the kind of detail any official record might deem worth recording.

It is 2021. Over a period of several months, I visit the artists Gabhann Dunne, Cecilia Danell and Philip Moss in their studios, and I write about their work. My world begins to get bigger. I start eating again. I start to write with a kind of clarity I have never felt before. And I start to sing, although still mostly to myself. My marriage is broken, and I have broken something in myself too, and it is good.

Healing

I<small>N</small> J<small>ULY</small> 2021 I <small>OPEN THE</small> internet to discover that the French artist Christian Boltanski has died. I hadn't read about his work before. I don't know why. I read a tweet that refers to his Les Archives du Coeur, which translates as The Heart Archive or archives of the heart. The tweeter writes, 'I'm not sure if his own heartbeat was recorded as part of it but hoping it's pounding away.'

Imagine an archive of heartbeats. Bump. Bump. Bump.

The tweeter is an artist and researcher at the Courtauld research forum in the UK, Dr Grace A Nagle. An art curator in Ireland called Aisling Prior, has replied to say, 'First "proper" contemporary art in a gallery exhibition I saw was his in Paris in the 80's. That was it for me. I knew I had to work in the visual art world.

In the Gallerie Ghislaine Hussenot. I remember it so clearly. Electrifying.'

Bump. Bump. Thump. Prior describes so well that moment of zing that happens when art hits home, head, or is it the heart? A heartbeat is an electrical impulse. A moment of zing is one too. An action, an insight, an experience, that cuts through everything, making purpose and path clear: follow your heart.

Christian Boltanski was born in Paris in 1944. The description of him on the Archives du Coeur website reads a little strangely:

> Explores themes of life and death in a variety of media, including video, photography, painting, sculpture, and multimedia installations. In addition to attempts at recreating personal histories, Mr. Boltanski captures memories of anonymous individuals through cookie tin-boxes, candles, thousands of photos, articles of used clothing, and personal names, among other things, to express the importance, transience, and fading of human existence.

This website doesn't know he is dead yet.

Les Archives du Coeur dates from 2010. It's the permanent home of audio files containing recordings of heartbeats, which Boltanski has been making since 2008. The website says, 'Les Archives du Cœur is a testament to the recordees' existence. The recordings may be listened to by visitors. It is also possible to record your own heartbeat here.'

I repeat the words staccato. Heart. Beat. Here. The website details the admission and recording fees: 'Recording Fee: JPY1,570 For recording and the CD-booklet. You can bring a CD-booklet of your heartbeats home.' I repeat the words. Heart. Beats. Home.

It's only then I realise that the permanent exhibition is in Japan, in Naoshima. At the Archives du Coeur in Japan you can purchase a recording of your own heartbeat as 'an original CD booklet'. The only place I can play a CD now is in my car. I didn't take a CD player from the items listed in the spreadsheet of possessions that accompanied my divorce, but I do still have a box of CDs. Imagine driving to the sound of your own heartbeat? Imagine driving to the sound of others.

The heartbeats I have lived with are my children's, inside of me. And my own. Mine is complicated. The shop at Naoshima sells a letter set, which the website, in its curiously evocative English translation, says, 'implies the message of our desire for you to share your experience at the museum with others'.

I will share with you some of my experience of hearts.

When I was six, my grandad died of a heart attack. He was my mum's dad. It was the first time I saw my own dad cry. That summer of 1982, my sister and I would sit on the wall, sipping water from washed

out shampoo bottles, waiting for the binmen. They pulled up in their filthy truck with hefty cries of, 'Hello boys!'

'We're not boys!' we would shout, indignant.

'Well, you're babies then, drinking out of bottles,' they said.

'No we're not,' we would squeal, giggling as we clutched the squeezy plastic containers, squirting water into our mouths from various arm-length distances as we experimented with the perfect balance of liquid arc and squeezy force. The binmen were the big thing that summer. It was a summer too of hopscotch and the ice cream van and playing with kids on the road. We were only staying six months.

Ours was a 1970s-era bungalow, rented while my engineer dad was on a temporary work transfer to Cork. Set in a circle of others with triangular roofs peaking around a grassy green, it was a house of lime patterned carpets and a sunken living room. It was a temporary home and also the house where my grandad had the heart attack that killed him.

Somehow my six-year-old enthusiasm for the binmen's appearance crossed over to the arrival of the ambulance. My mum, presumably panicking, presumably trying to keep us two, aged six and three, out of the house, got us to stand on the bank near the entrance to the housing estate and told us to wave to let the ambulance men know they were at the right place. Our excitement as they screamed past, sirens blaring,

verged on mania, a combination of exhilaration and unspoken fear, sparked by our mum's odd behaviour. They came past twice more, before turning in. No mobile phones, no GPS, in those days. After that I remember nothing. Except that I saw my dad cry. My mum was twenty-nine.

I think I carried a lurking feeling for years about the enthusiasm with which we cheered and whooped on the bank as the ambulance passed. Somewhere, I absorbed the idea that my grandad would not have died if the ambulance had been quicker. Part of me wondered if we had not tried hard enough to attract the driver's attention as we leapt about on the roadside embankment.

We were both small. No one told us anything was really wrong. And everything new was exciting, even the arrival of an ambulance that screamed to a halt as it parked on top of our hopscotch game.

When I was a teenager, I went to France on a language exchange. I came home with second-hand clothes bought in a kilo shop, a fresh understanding of my own privilege, new horizons for my own independence, and some postcards with quotes in French, which I hung on my bedroom wall. *Le coeur a ses raisons que la raison ne connaît point* – Blaise Pascal. I translated this quote from a seventeenth-century French philosopher as, the heart has its reasons that reason knows nothing

about. It was a good quote for a sixteen-year-old often torn between head and heart.

Is writing a way of connecting heart and head? I am reading a book called *I Love Dick* by Chris Kraus. It says, 'The arteries of the hand and arm that write lead straight into the heart.' I spent my teenage years writing so many letters. I wrote them to friends I had left behind in Kilkenny and Carlow when I moved to Cork. But I was writing them before that too. I wrote to people I saw regularly. I wrote to a friend who had been with me in primary school but went to a different secondary school. I wrote letters for connection, I wrote them to receive them, I wrote them to put narrative shape on my life, to articulate my experiences. And I wrote them when I fell in love.

My first boyfriend and I amassed envelopes of letters even though we saw each other almost every day. We did not post these letters to each other. We handed them over, to be read at home, later, when we were not together. Or again when we were. We were writing ourselves and our connection into existence.

When I was born, my parents were told that I had a hole in my heart. A small one, not life-threatening, not probably even dangerous. In common parlance, a heart murmur. My granny had one too. I was brought up to remember that if I had dental work I had to have an antibiotic first, in case of a blood infection that could

travel to my heart and get stuck there in the anomaly and cause an infection *in* my heart. I grew up telling doctors as they listened to my chest and my back for heartbeats, 'I have a heart murmur. I've been told it's barely audible, but some doctors can hear it.'

Of course, nearly all heard it then, 'Oh yes', though one or two sometimes said, 'No, can't hear anything'.

'It's very small,' I would apologise.

The doctor who saw me when I was fourteen or sixteen at Crumlin Children's Hospital for a check-up said it sounded like 'ba-bum-csch ba-bum-csch' to someone listening through a stethoscope, a kind of swish, a kind of swoosh, as well as a beat, where some of the blood was pushed by the muscle through a tiny flap between my right and my left ventricle. No problem really, just a small gap in a place where there should be none. Nothing to worry about. 'Ba-boom-swish' I would say to doctors with inquiring faces, eyes focused on nowhere as they listened for the difference.

'It is very small,' they often said. I wonder now was it the sounds in their own ears. In their own heads.

The doctor in Crumlin drew me a picture on a pad pre-printed with a basic line drawing of an anatomical heart. VSD he wrote in the top right hand corner. And he told me what it meant: Ventricular Septal Defect. VSD I thought to myself. OK.

During the year I spent trying to figure out why there was endless buzzing in my ears, I went to see a cardiologist for a check-up. My husband suggested it.

The sound in my ears is the sound of blood. The sound at the end of a stethoscope is the sound of blood too. The consultant ran the same test they ran in Crumlin, an electrocardiogram, ECG. Then they did an ultrasound and looked inside. They didn't have that when I was fourteen or sixteen, or whatever age I was when I was handed the piece of paper I carried in the back of my wallet for years, even on my trip to France. VSD.

In his office, the images appeared on the doctor's screen as the nurse outside moved on to the next patient.

'Well,' he said, 'you don't have a heart murmur.'

'What?'

'Who told you that you did?'

So, I told him the story of the doctor and the children's hospital and how he drew me a picture and wrote the words VSD on a piece of paper and told me that they wouldn't be seeing me again as by the time my next check-up came due I would be an adult, over eighteen, or was it sixteen, and no longer on the system of the children's hospital.

'Did it close up?' I asked.

'No,' he said, 'this type of heart murmur doesn't close up.'

'But my granny has one too,' I said, adding that she was ninety already, so it hadn't done her any harm.

'Well, you don't,' he replied.

'So, it fixed itself?' I asked.

'No. This kind of heart murmur does not fix itself,' he said.

'A ventricular septal defect,' I said, 'VSD.'

'Yes.'

He was looking at me quizzically, disbelievingly, in a way that made me want to explain myself. 'I didn't make it up,' I said. 'There is no way I would have the term ventricular septal defect in my head if a doctor hadn't written it down for me when I was a teenager.'

The consultant said nothing. He was finished with me and my memories and the justifications, anomalies, and heart-faults by which I had formed definitions of myself, for myself. His body language as he closed the file said, 'next'.

I left, feeling strangely bereft. I paid the two hundred euros to the receptionist outside and confirmed that I did not need another appointment. There was nothing wrong with me. I left the doctor's office without a hole in my heart, having gone in contentedly carrying one for more than thirty years. Or at least having adjusted to the idea, having adopted the idea, maybe even having clung to it, having believed this thing was a unique part of what made me myself, a small damage that made me different, but nothing to really worry about.

It is a strange sensation to have a mild affection for a benign affliction that has maybe never been yours taken from you. It's unclear what you might actually be missing when it wasn't something anyone should have wanted to hang on to in the first place.

After my marriage broke, I started to think about the power and the frailty of the heart. I started to think about open hearts and closed hearts. I started to think about the stories we tell to protect ourselves. I started to think about bodies and hearts that heal themselves. The human body can recover from great trauma. Cells can grow back, bones do knit, tissue can regenerate. Can the heart physically heal itself? I check with Harvard Medical School, and find an online Q and A:

> Until recently, it was believed that the human heart didn't have this capacity. But the heart does have some ability to make new muscle and possibly repair itself. The rate of regeneration is so slow, though, that it can't fix the kind of damage caused by a heart attack. That's why the rapid healing that follows a heart attack creates scar tissue in place of working muscle tissue.

I find a news story with the headline, 'Secrets of Healing the Heart Discovered in Zebrafish Studies' and sub-heading 'Zebrafish can heal their damaged hearts. Human hearts retain scars of earlier injuries.' The article goes on to relate how 'Scientists in Australia have found that Zebrafish, which are freshwater fish native to South Asia, can regenerate heart tissue after ventricular injury. They have a genetic switch that controls this.' Dr Kazu Kikuchi, the senior researcher, tells the reporter: 'Our research has identified a secret switch that allows heart muscle cells to divide and multiply

after the heart is injured. It kicks in when needed and turns off when the heart is fully healed.'

They think maybe it can help heal human hearts.

'In humans, where damaged and scarred heart muscle cannot replace itself, this could be a game-changer. With these tiny little fish sharing over 70 per cent of human genes, this really has the potential to save many, many lives and lead to new drug developments,' says Dr Kazu Kikuchi.

Heart ache. Heart break. Heart fault, heart fix. Did I fix my own heart murmur? Or was it never there in the first place? Which story is the correct one? Does it matter?

I bruise easily. After my husband moved out, people who had never noticed this before started to see the bruises and ask in that casual-non-casual way. What happened to your arm? That's a big bruise on your leg. You've got it all wrong, I wanted to tell them, the real scars are on the inside, in my head and my heart.

A revelation of marital infidelity is like a gunshot to the chest. It hits all those instinctive, ephemeral, physical places we hold in that torso cavity: heart, lungs, gut, soul. I can't breathe, and yet I do keep breathing. I am stunned into silence, and yet soon I will scream. I can't move, and yet I do run. And it seems afterwards that something remarkable is going on if you are still standing.

I used to be a much crueller art critic. In 2004, I wrote a review for *The Sunday Times* of an exhibition of new works by the Italian artist Francesco Clemente at the Irish Museum of Modern Art.

I wrote,

Valentine's Day has been and gone but hackneyed sentimentality and overt symbolism are alive and well at the Irish Museum of Modern Art (IMMA). They are to be found in the recent watercolours, oils, pastels, and frescos of Italian artist Francesco Clemente, in which pierced hearts adorn sparse trees, honeycomb eyes drip big yellow tears, stylised figures kiss and caged birds sing.

Clemente had international superstar celebrity fans and had mounted a major Guggenheim retrospective in New York and Bilbao in 1999 and 2000, but this Dublin show included only work made in the four years since then, much of it being shown for the first time. I wrote, 'no form of discrimination appears to have gone into the selection of works.' I wrote that the show was 'cloyingly self-indulgent'.

I wrote that his metaphors and symbolism were 'clangingly blunt'.

I wrote that twee metaphors and familiar motifs were his calling cards, and that, 'like most of those Valentine's missives it's difficult to believe the sentiment is any more than paper deep.'

I think I was annoyed that Clemente's work wasn't

punching me in the gut. I think I was disappointed
that this artist was happy to make safe, unchallenging
paintings, when the heart in art can be so powerful.
I was also enjoying the job of putting words together
that could make that kind of argument with a flourish.
The New Yorker art critic Peter Schjeldahl once wrote,
'effective criticism usually has elements of performance
art'. I can see now that while I am busy writing about
Clemente's failings in his symbolic use of hearts,
neither of us is saying much about love.

It is 2016 and I am sitting in a deconsecrated church
that is now part of an arts centre in Cork city. Triskel
Christchurch is hosting the launch of volume 2 of the
literary journal *Winter Papers*, and the poet Doireann
Ní Ghríofa is reading her poem called 'At Half Eleven
in the Mutton Lane Inn, I am Fire, Slaughter, Dead
Starlings'. I love Ní Ghríofa's poetry and, more particu-
larly, how she performs it. Her presence is the reason
I am there. What I remember is that she also read a
prose piece about a human heart that had been found
in the basement of this church.

The heart of this unknown person was found encased
in lead in the walls of the crypt under the Christchurch
building in 1863. No one knows whose heart it is, no one
knows when it was first placed there. It was bought as a
curio by General Pitt Rivers, an archaeo-ethnologist then
stationed in the city, and is now part of a collection of
artefacts housed in the Pitt Rivers Museum in Oxford.

In 2017, another artist became interested in this heart. Dorothy Cross had a vision for an artwork that would bring it temporarily back to Cork. It would travel by boat up the river back into the city accompanied by song and the sound of glass harmonica and waterphone. Heartsounds that are not a heartbeat, on a Heartship. The word Heartship, which is the name of Cross' live performance piece, is a hair's breadth away from the word hardship.

In 2019 I take my children to see Heartship as part of the Sounds from a Safe Harbour Festival. I take them to stand on the quays in the Port of Cork and watch the slow arrival of an Irish naval vessel carrying the unclaimed, unknown, undated, forever preserved heart, and the singer Lisa Hannigan who walks on deck as her voice carries a heartsong broadcast from the boat. There are words, but the sound is more important than the language. It is also a wordless lament, for the hearts of migrants, who Cross says, 'lie unnamed on the sea-bed', for the lost heartbeats, the forgotten sounds that connect us.

The artist Cecily Brennan makes really good work about pain and healing. She made a film called *Unstrung* in 2007, in which a female figure in a white windowless room is knocked off her feet, again and again, by a wave of black water. Her 2001 sculpture, *Bandaged Heart*, is bigger than a human heart at 17cm deep. Cast entirely in stainless steel, it's a heart hand-tied with a swatch like a headscarf.

I wrote about another of her works, the film *Black Tears,* in 2011. In my notebook, I wrote,

It begins. A woman is crying, tight-lipped, tears falling. She closes her eyes and emits a sound from the base of her throat. 'Oh. Oh, ph-p-p-ph ...' She lifts one shoulder and tilts her head as if to offer herself some kind of comfort. Then she shakes her head, lowers her shoulder and cries. She looks up, closes her eyes and sobs.

Then all hell breaks loose: the woman goes from sobbing to roaring. When she looks, briefly, toward the camera she doesn't register that we are observing her, watching as she makes invisible anguish visible, witnessing the transfer of pain from the inside to the outside. Later, a second wave of grief will overwhelm her, and she will roar again, wringing her hands in despair, and she will see us. Her eyes will flicker as she acknowledges the camera, turns her head away and stops. In the meantime, we will have noticed that although she is wearing no mascara, the woman has begun to cry black tears.

When it comes to submitting this piece for publishing in *The Sunday Times*, I change the start of it because journalism demands a story with a little more context to begin. The article opens with the words,

When asked in 1999 if her work was informed by personal experience, the artist Cecily Brennan dodged the question. 'Everybody has experience of damage and injury,' she told Peter Murray of the Crawford Art Gallery in Cork. Brennan had just completed a series

of polished stainless steel sculptures that were uncomfortable to look at. They included Knee Replacement (Middle Age), with its long stitched scar running over the knee-cap, and Hinge-Ons for Bad Days, a pair of calf-and-shin-guards with more surgically stitched flesh and an ugly looking skin-graft.

Even then, Brennan was cautious about attaching narrative to the images and objects she produced, circumspect about telling stories that might pigeon-hole her work as a form of 'self-help' or anything else. Twelve years on, she has returned to the Crawford with her latest project, an eight minute HD video that plays on a loop in a darkened room. And it is likely, if Murray put it to her again, that she would answer the same question in the same way.

I follow a journalist and digital news expert called David Clinch on Twitter. When I teach journalism skills for art writing, a series of lectures in what I sometimes call 'Critical Journalism', I use a quote he once tweeted: *Journalism is making the important interesting.* I think art is making the interesting important. Art is a desire to show other people how you see the world, or an enactment of that. Art is making how you see the world manifest in it.

The writer and critic John Berger once wrote, 'I do not recommend art criticism as a life-long profession … What I recommend is a bout of five years or so of criticism – and the image of a bout is not carelessly

chosen.' He also said, 'the only justification for criticism is that it allows us to see more clearly.' Art helps us see more clearly, even when it is floundering, experimenting, failing.

When it comes to the human heart, maybe facts are less important than the stories we tell ourselves. Maybe they both contain truth.

After I go to see the heart doctor and he tells me I never had anything wrong with my heart, I tell my mum, 'I fixed myself.'

'I always knew you could do anything,' she says.

Heart ache. Heart break. Heart fault. Heart fix. Heart beat. Heart beat. Heart ache.

Still here.

Home

T HE FIRST TATTOO I GET AFTER my divorce is for me. The second one is for my grannies. A tattoo is a line drawn between then and now, a beautiful, purposeful channelling of pain that means something more than the ink. The outline is the least painful part. It's the filling in that digs deep.

Life puts scars on our bodies we didn't ask for. Marriage felt like a surrender of my body. This was stamping myself with marks I chose. Fourteen hours of good, useful pain to connect me back to my body, my home inside.

I think, this is one way of expressing, containing, transforming pain from inside to out. I think, this is also a way of feeling something else, something understandable, something that makes sense. In the same

way my stomach growling because I have not eaten makes sense; there's a reason for it, I understand the cause. Tattoo pain heals, leaving a deliberate mark and an absence of pain instead. Even better, a tattoo is art you can carry without holding. It's art you can take with you if you need to run.

A tattoo cannot be listed, claimed, or divided up, unlike the process of splitting possessions, including works of art once selected for a home together. Post-divorce, there is also something hugely satisfying about buying art that will only ever exist on your body, and putting it in a place you know your ex will never see. Tattoo number two is also for the possessions I can't take with me when I leave my home on the side of the mountain, because there are some things that must stay put. These are living things, deep rooted in the ground. They're not going anywhere. I'm the one on the move.

When the kids and I finally move into our own new house, sleeping on blow up beds and eating dinner in deckchairs because I have sold my half of the furniture left in the family home in order to maximise my cash, I paint a new mantra on the wall. It's a sentence that came to me once when I stood on the Beara Peninsula in West Cork, as I rooted bare feet into the camomile grass and stared out at the Atlantic Ocean: *The ground will hold you where you stand, remember you are free.* I repeat it under my breath. I repeat it when it feels like I might come untethered, and I remember how to stay heavy, and light.

A marriage ending breaks a home. After a while, it became clear to me that the most unforgivable thing I had done in the eyes of some was to take the family home apart, to destroy the very concept, almost delete the very place, by insisting on its sale. I wanted more than anything to move on. I could not move on and stay put, in a home we had built together, in a place where we had no roots.

I want to stay tethered. I don't want to come undone. I look back, to find anchors and roots.

On my mum's side there were journalists. My great-great grandad owned newspapers in Derry and Donegal. In December 1921, he announced that his twenty-four-year-old daughter Eily McAdam was taking over as manager and editor of *The Donegal Vindicator*, a newspaper printed and published from a building that was also the family home. In London, a treaty had just been signed to establish the Irish Free State. It would draw a line that split the rest of the island from six counties in the north, along a border with Donegal, keeping that northern county in the Irish Free State. But the treaty had not yet been ratified in Dublin. Anti-treaty and anti-partition, Eily still wrote about peace and compromise. She had been arrested for her first journalistic 'venture', as her father put it, by the British Army in 1920. They raided the *Vindicator* premises, shut the newssheet

down and took Eily and her younger sister Kathleen to Armagh Jail where they were later released without charge.

As editor of the *Vindicator*, Eily continued to hold a Republican editorial stance throughout the Irish Civil War, which was likely the reason that the military wing of the Irish Provisional Government, the National Army, also raided the premises, by some accounts smashing the printing press. But Eily kept publishing the paper. In her first editorial she wrote, 'I do not think anyone can hold a conviction dear and cause his pen to be silent on the subject or to write otherwise than he thinks.' She stepped down as editor abruptly, in April 1923, two months before the end of the Irish Civil War. I don't know why.

She married but kept her own family name in print, writing for newspapers in London and Dublin. I found her in the 1940s in *The Catholic Standard*, writing a regular column called 'Notebook', where she observed, 'Robert Louis Stephenson was of the opinion that no wise man would ever marry a woman who writes, because, he declared, the pursuit of the right word and the uncertainty as to whether it has been found was sure to lead to moodiness.'

The danger of words. The danger of women and words. I wonder about the unpublished personal stories of women who write, there to be found in the gaps.

In 1949, Eily wrote, 'The "I" pronoun does not often intrude in this column, but it is coming in this

time, because there seems no other way to tell the story effectively.'

Writing, reporting, attempting to put language on the truth, some truth, a truth, are part of who I am. There is newspaper ink in my blood. It is also baked into my ancestral understanding of risk: the risk of publishing dearly held truths; as well as my notion of home. Pa was widowed twice. I am descended from his first family, so my ink-blood comes not from Eily and her descendants, but from Pa, John McAdam, the original Peripatetic Pressman of the North of Ireland Publishing Company.

By 1901, his eight children, aged one to twenty, were motherless at 7 East Port, Ballyshannon where Eily grew up. It's a building that no longer exists. When I look, I find a gap in the terrace, an empty space. No-one's home now. Pa was born in Glasgow, Scotland. Eily was born in Dublin. Maybe my family have always been blow-ins, on both sides. Maybe that's why I feel comfortable with moving, again. Maybe words are all that we carry with us.

On the other side of my family: architect and boat builder, migrant too. My grandad Oscar Leach was recorded as an 'alien' whose official status as an Irish citizen was read into the records of Dáil Éireann in 1947, along with a list of others now 'naturalised'. He had moved with his wife Norah from England in 1939, bought a plot of land with no services 1,000 feet above Dublin Bay, and built a house by hand at

Ticknock in the Dublin Mountains. A newspaper holds the record, again. *The Irish Times* reported in 1950: MAN STARTED TO BUILD HOUSE WHEN HE HAD ONLY £30 CAPITAL. Under a photo, a caption reads, 'Obarlann Muire, the house that was built by a man who, when he started work on it, had a capital of £30 – or rather £2 18s. 0d., after the land had been bought and legal fees paid.'

Obarlann Muire means Mary's Laboratory, or Mary's Workshop, in Irish. Oscar was born on the Isle of Man. He learnt Irish to pass the necessary language test to get a job as an Office of Public Works architect in Ireland. The article describes how, 'Each Saturday after work, he walked six miles over two mountain ranges from Glencree in the Wicklow Mountains to the site at Ticknock, laboured until it was dark, and walked back to their rented cottage.' He started building in 1942. In 1944, they moved in, essentially camping as the work continued. They had a well, a chemical closet, paraffin lamps, hens and a cow, and grew their own vegetables.

I remember this house too, its hefty weight of hand-trimmed, hand-laid granite walls, and its curious extensions. A high-ceilinged, open-plan living-dining room with a suspended sleeping gallery. A low-ceilinged bunkroom with beds like a ship's cabin, added as the family expanded to include seven children. There isn't a word from or about my grandmother Norah in the article. Three days after the newspaper report, a letter to the editor appeared.

Sir, – Your Special Representative's most interesting article on the single-handed building of Obarlann Muire (in last Saturday's issue) would have been doubly valuable to readers wishing to follow in Mr. Leach's footsteps had it included some of his wife's impressions. To my way of thinking Mrs. Leach is the partner to whom the greater praise is due. Her confidence in the ultimate outcome of her husband's project must have been vital, else how could he have persevered? She endured all the aloneness in far Glencree in the early stages, as later she overcame the trials and heart-burnings of bringing four little ones into the world in such pioneer circumstances. Think of her single-handed in the dark winter evenings getting the latest arrival to bed, keeping the others quiet and preparing her good man's evening meal – that would be only a fraction of such a housewife's difficulties. As the wife of a mildly similar husband who only had to endure the comparative primitiveness of a week-end cottage, may I salute Mrs. Leach as a heroine and a good sport? – Yours, etc., E.M. Dublin, January 9th, 1950.

I wonder who E.M. might be? My grannies married clever, ambitious men. Both were clever, talented women. Norah Meyrick, born in Bushmills, County Antrim in 1913, was completing a botany degree when she met Oscar in Liverpool. She was more likely to be found writing letters to the editor herself. In 1966 she founded the Irish branch of La Leche League, after she

read an article about the international breastfeeding support organisation in *Readers Digest*. Bridget Clarke married John McAdam, descendant of the newspaper man whose name he shared, having come to Dublin from Ballyhaunis in County Mayo in her twenties to work in a shop. She loved fashion. Neither of my grannies had paid, professional careers after marriage and children. Ireland had introduced a ban on married women working in 1933, which lasted forty years. Neither of my grannies had independent financial autonomy. They had three boys and nine girls between them.

Women's personal ambitions sometimes go on hold to build families and homes with the men we marry. I am asking myself, is it only worth it if the household holds? What happens when the foundations fall apart? Some ambitions might come back if it's not too late. But first, everything smashes to pieces. Everything.

It is 2016. My husband has moved out and I am looping and looping in the house. I check windows and doors to make sure they are locked. I find it hard to leave. I don't really want to leave. The house is an anchor and a trap. The house holds me. I am trying to find myself. No, that's not right. I'm trying to lose myself. I'm trying to disappear. It's only later I want to start to live again. A dysfunctional home is a dystopia.

What is wrong with the house? I cannot eat. Everything tastes of mould and then, later, of soap. This goes

on for two years. I call my friend panicking. I have found receipts for dinners I did not eat, hotels I have not stayed in. 'Press-ups,' she says, 'drop and do five press ups and then call me back.' If I do not channel this adrenaline somewhere it will bowl me over, it will render me mute, it sends me in loops about the house, endless circles of thoughts and actions, it will kill me. I know too that not eating is about fear. It's about being ready to run, at any moment, fast. It's about being able to hide. It's a perverse attempt to survive.

I realise I have to stop checking locks the day I find myself looping in a multistorey car park. I keep going back to the car to check that I have locked it. I know I have locked it. But every time I get to the lift, my mind says 'wait. Just check, did you really lock it? Did you? You better check.' I devise a solution in the moment. I will go back, and I will check the door handle five times and I will count, and then I will say to myself, 'the door is locked.' And then when I get to the lift and it happens again, I will tell myself to remember that moment. The moment when I counted and confirmed and said to myself, the door is locked. And I will tell myself that this is true and that I must not go back. And it works, except a small part of my brain adds, even if it's not locked it's ok because this is a multistorey car park, and no one can steal your car without an exit ticket.

This is anxiety. This is panic. This happens to me in the house at night when I am alone. I check every

single window and door. And then I check them again.
I am not ok. But I start to recognise this as a pattern, a
pattern my brain has devised to keep me safe. Because
I don't feel safe. And home is meant to be a safe place.
Home is refuge.

We agree to sell the house and the children ask,
'where will be home?' I tell them, 'home is wherever
we are together.' I have moved so many times in my
life, I know that this is true. I don't have a one-word
answer to 'Where are you from?' and so I am sure it
will be ok if the kids do not either. They have already
moved twice, although they don't remember. We built
this house on the side of the mountain and moved
into it when our children were one and a half and
three. I try to imagine growing up in one location,
all your childhood and teenage years spent coming
home to the same house in the same place. Irish
people love to ask, 'where are you from?' I always try
to compress my answer, make my nomadic history
more compact.

I went to three primary schools and two second-
ary schools because we moved with my dad's job as a
hardware service engineer for an international com-
puter company. My parents decided to stop being
Catholic soon after I was born and sent all four of
us to Church of Ireland schools. 'Where do you come
from?' I remember a little girl in my Irish dancing

class asking me which school I went to and telling me her mammy said she was not allowed to talk to me because Protestants had black money.

The day we left the childhood home I had lived the longest in, from age six to fifteen, my granny McAdam came from Dublin to say her own goodbye to our 200-year-old farmhouse in Kilkenny. She snuck off with a disposable Kodak and later printed a photo-journal complete with rhyming captions. It was a record of a place that had been home and fantasy wild playground to me and my sisters, and a dream rural retreat for my Dubliner parents, for ten years. We had hens, and a goat and our own vegetables.

Granny's ditties captured outdoor places we knew intimately. 'Curling walls and bent wood trees; And daffs nodding in the breeze.' 'A ramble on the "lazy lane"; And the stream runs over the stones, so clean!' Next to a photo of my sister and me climbing the ancient apple trees, Granny wrote: 'An easy climb on bend and crook, gives vantage point for a better look.' This place was an idyll I have already spent some of my adult life trying to find again. It was home.

But where I come from is people and ideas, not place. Place is so important, but place is a moveable connection because people are mobile. We can choose home again and anew. We cannot choose the layers of history and people behind us. Those are staying put.

My mum is an artist. In 2010, she started to make a new body of work called *The Future is Left Behind so Many Times*. Every time we move house, we leave one potential future behind us. Every time something happens to drastically alter the plans we made, the hopes we once had, the future we anticipated disappears unlived. My marriage ending is one of those times.

My mum makes artworks in which the image of the gable end of a house dominates. She makes artworks in which pins from a sewing box pushed through roofing material from a building site form a spiky shadow house shape. She uses pins to articulate a pattern on a curved roll of what she calls *Anxiety Wallpaper*. She makes woven tapestries based on the shape of the footpath her father laid in their garden, down which she used to skip as a child.

My dad loves words. He writes a novel about some men crossing the Atlantic in a sailing boat, as he did with a group travelling over 2,700 miles as crew in the ARC yacht race while I was in college. When I was in secondary school, he made a fourteen-foot sailing boat by hand in our kitchen and back garden. Just like his dad had done when he built a boat up the mountain in Ticknock. Both my parents make and fix things with their hands and their heads. Both my parents love language and words, both know there is more to be found in what is said between the gaps, between what is seen and unseen.

When I started writing again, after my daughter was born and more than a year had passed, I wrote about home. I had temporarily lost my role as a critic. I had no outlet asking me to produce words. I had no reason to write them. I wrote a piece for a series on RTÉ Lyric FM called *Quiet Quarter*. The commissioning editor wrote back to say that he liked it but would need four more, to make it a sequence of five pieces that would last a week if he was to broadcast them in the slot. I tried to add another four, but I was forcing words into a format not mine, and I didn't have enough good words to make it work.

I wrote about the first home my husband, my kids and I had lived in as a family, the first house I brought our babies home to, in Dublin. It was a 1970s three-bed semi outside the city. You could see Ticknock from the back bedroom window.

The owner was there when we went back with the surveyor on the day we decided to buy it. She wanted to know if the house had hugged us when we walked in. 'I'm a bit of an eccentric,' she said. 'I hope you're not ordinary, whatever you two do, you mustn't be ordinary.' Her home was full of objects, furniture and works of art from all over the world. The plastered back garden wall had children's handprints embedded in its surface. Kids who lived on the road had been invited in to leave their mark back in 1975.

I cried the day we decided to buy this house. We weren't married yet and we didn't have kids, but I was

afraid of something, and I didn't know what. The house had hugged me alright. I felt it sucking my independence and freedom away as it squeezed.

It is September 2010. We have been living on the side of the Galtee Mountains in the home we built for our young family for one year now. I've been asked by Dublin's Science Gallery if I'll give a talk at the Electric Picnic Festival. It's a five-minute talk with twenty slides that auto-advance every fifteen seconds. The format is described to me over the phone as the crack cocaine of public speaking.

I do not have a paying job. The editor who once described my articles as a car crash has dropped me from my freelance gig. I've had two babies in quick succession and had not been available for work. My talk is called 'Femme Maison', which translates as Housewife, but also maybe Woman House, House Woman. The event host introduces me: 'Cristín Leach started her career as an eight-year-old book reviewer for the RTÉ Guide. She grew up to be an art critic ...'

I have been at home with two children under two since December 2007. I have not published any writing since before my second child was born.

I begin,

This is a meandering, personal tale, inspired by the artist Louise Bourgeois, who was 98 when she died this year.'

I continue,

> *In my split personality life, I am not only an art critic, but a yoga teacher. A perinatal yoga teacher. Which means I teach pregnant women, amongst other things, how to breathe, and be calm.*

I am showing the audience an image of Bourgeois' famous pink-hued print featuring an egg shape and the words Be Calm.

I say,

> *Bourgeois had three sons, like steps. The first adopted. The second two, born in the 1940s, like gifts she thought she couldn't have. And then she struggled and tussled in the battle between maternity and creativity. She described her 'mother-love' as 'ferocious'. And she said, 'God invented art … as a survival device.'*

The works she called 'Femme Maison', began in the 1980s. Literally, Woman-House, or Housewife. She said, they sprung from the feeling that she didn't have the right to have children, or to be an artist. Like a good Femme Maison, she said, 'I felt I had to save my husband's money rather than do sculpture that cost money. So the materials I used in the beginning were discarded objects.'

I say,

> *The Irish sculptor Melanie le Brocquy, a near contemporary of Louise Bourgeois, and sister to the more famous Louis, showed at the Royal Hibernian Academy in her*

teens, but stopped making art after she married a doc-
tor at twenty-four. 'We had four children,' she said, '... I
didn't start sculpture again until I was forty. I began
with – of all things – plasticine.'

Bourgeois talked in an interview with Marie-Laure Vernadac first published in 1995, about wanting to eat her children, 'It's true that I try to eat my children when they irritate me, but I don't want to show that in public. I want to hide that cannibalistic, aggressive side of me ...' She told Vernadac that a lot of her personal drawings should never have been shown in public. 'My friends the dealers found them. There are a lot of things I should have weeded out.' Vernadac asked, 'Were they intimate, personal notes, for your eyes only?' Bourgeois said, 'Yes, they shouldn't have been published.'

Bourgeois said of this particular drawing which I show during my talk, 'I'm eating it.' She means the baby. 'I'm stuffing my face with it, because I don't know what to do with it ... I want to abolish them, because they are a fact, because they are such a huge burden. The only way of making them disappear is to eat them, the way spies during the war used to get rid of evidence by swallowing it. I'm against children, but at the same time I think they are the most beautiful thing in the world ...'

I show an image of the oil painting my mum made of me as a child.

I say,

My mother went from painting oils like this of me, to weaving. When I asked her why she chose weaving she said, 'You can leave it and go back whenever. You can abandon it when the kids need you.'

I grew up around tapestry and weaving. For as long as I can remember, on the kitchen table, in the living room, in a studio space when there was one: looms, threads, warp, weft, colours, fibres on the floor. Feelings, thoughts, emotions being woven into art. You can't change the past, but what if the past does change because it changes with perspective? And it changes depending on who is looking at it.

I was born in January, a month named for the Roman god Janus. He had two faces, one to see the future and one to see the past. All my life I have felt the key to the future lies in understanding the past. But there is no one past, the past is a confluence of what is remembered and forgotten, hidden and visible, seen and unseen, said and unsaid. And there is always more than one story.

When the agreement is reached to sell the family home and the kids ask, 'Where will be home now?', I tell them, 'I am home, you are home, wherever we are is home.'

In 2016, as our legal separation process is slowly progressing, I attend a writing workshop. I write a very short story:

Sarah has a memory that will not desist. It repeats in her head now more than ever. It comes back because of the anxiety.

The car stops and her mum gets out, glancing quickly left and right as she crosses the road to the phone box. She makes a call. Presses the A and the B buttons, in what order small Sarah does not know. The money drops. She tells where she is going. She gets back in the car and drives with hands shaking, getting calmer as she gets closer to Dublin. At Henrietta Street she bangs on the door. A window opens above and keys are thrown down. She doesn't catch them. She lets them drop and picks them up from the hard, concrete steps. In the hall, dusty, dark, old bicycles. She bundles her two small girls up the stairs. One of them is Sarah. They sleep on a mattress up a ladder in a space like a shelf that cuts half way up the wall of the tall, tall room with the tall, tall windows and the open fire and the grey floorboards. Some with holes, don't step there. Blankets, lots of different blankets. And it is cold, despite the fire. The windows are thin. Sarah doesn't remember driving back, but she knows that they did. She doesn't remember ever leaving again.

Sarah tries to remember this as if she is her mother, from her mother's point of view. But she can't. She tries to remember details other than the phonebox, the keys falling, the dark hall, the dust, friendly strangers in the

tall, tall house, but she cannot. She doesn't know how long they stayed. One night? Not a night at all? Did the sisters curl up on that mattress for a nap only?

She doesn't remember why they left or what happened when they went back. Memories without words are out of reach. She is a mother now too and all she has is gut feelings about how everything we do is driven by an impulse above all to protect the children.

I have been making photo essays of my experience of the family law system. Private photo essays for no one but me. The first day we go for our divorce hearing the case is deferred. I take photos of my feet. I have photos of the window that looks out onto a wall in an alley about an arm's length from the next building, that I took when my solicitor left me alone to compose myself during one of our meetings. In that room, I was losing my grip. I was floating away. My brain glitched as my body panicked. I looked out the window and transported myself back to a place where I knew I was grounded: the Beara Peninsula in West Cork. I felt the grass under my feet, the wind on my skin, and my eyes settling on the horizon where the vast expanse of Atlantic Ocean meets the sky. I rooted to the ground in an office in Cork City and let the wind off the coast in my mind take the panic from my body as I breathed out. I took a photo of the room. The photos are visual anchors to hold me in place.

In 2021, I attend the Family Law Court in Cork for a hearing about child maintenance. Even post-divorce, debate about what is best for the children keeps you dancing together out of tune. As I wait, I look up and I see something. I think, that looks like some art up there near the ceiling in this double-, triple-storied space. What is that? I have been in this lobby before, and I have been so absorbed in my own pain that I have never looked up and seen this work.

I search and find a label on the wall. It is by the Irish artist Maud Cotter and it is called *House*. It was made and installed the year our son was born. Birch ply and steel cable, two and a half by four and a half metres tall and wide. It is an abstracted form hanging guillotine-like, curtain-like, building-block like, a deconstructed domestic dwelling in a space where family homes and families are being legally dismantled, officially broken up and divided, because they already are broken.

Leaving home is a kind of grief. Marriage is a kind of home. The most effective trap is the one you walk into yourself. The most effective trap is the one you don't leave even when the cage door swings temporarily open. But home is not a trap, and a trap is not a home. I have moved house, moved home, many times, fourteen now that I can count. Where is home? Home is here. Where do you come from? You come from inside your-

self. Home is your heart. Home is the self you emerge from into the world, and home is a refuge as long as you can keep a hold of your self, and keep re-making the future, each time it is left behind.

Acknowledgements

To D and G. Thank you the most. Thank you to my family. I love you so much. Thank you to my friends. I wouldn't be here without you. Thank you to the women of the three book clubs I have been so very lucky to have had in my life. Thank you to Lia Mills and the participants of the 2016 Farmleigh writing workshop, to the Coffee, cake, words occasional trio, and the Write With group. To Conor Graham and all at Merrion Press for their faith in this book, and to Noel O'Regan for the wise copy-edits. To the artists, writers, curators, editors, producers, and commissioners without whom I could not have done any of this work. Thank you too.